GLASGOW
IN
50
BUILDINGS

MICHAEL MEIGHAN

AMBERLEY

To The Mungo Boys

First published 2016

Amberley Publishing, The Hill, Stroud
Gloucestershire GL5 4EP

www.amberley-books.com

British Library Cataloguing in Publication Data.
A catalogue record for this book is available from the British Library.

ISBN 978 1 4456 5591 8 (print)
ISBN 978 1 4456 5592 5 (ebook)

Typesetting and Origination by Amberley Publishing.
Printed in Great Britain.

Contents

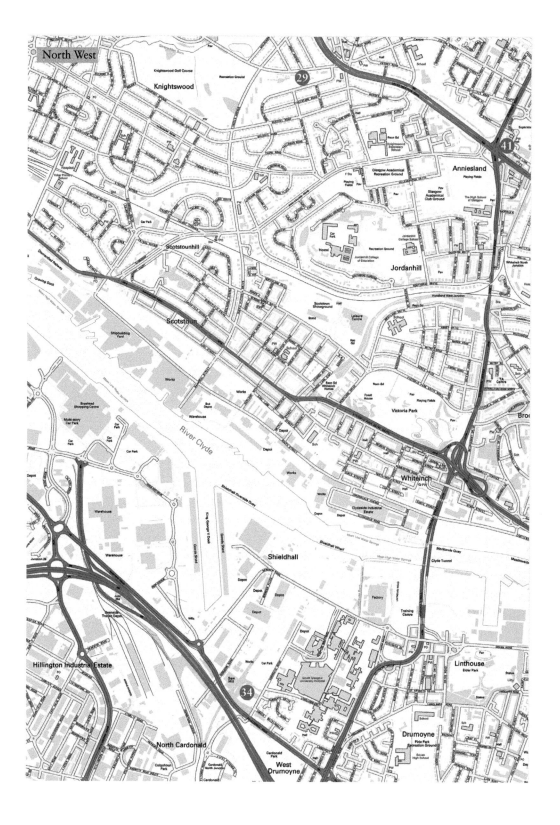

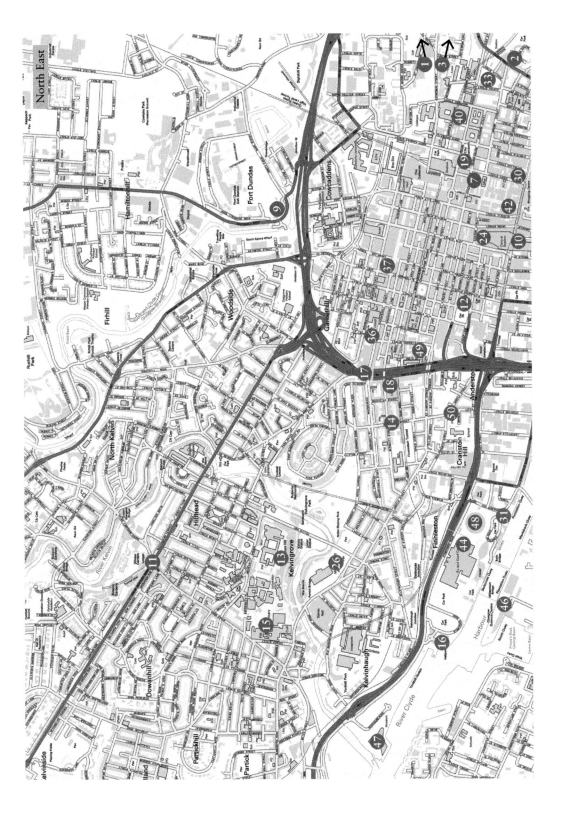

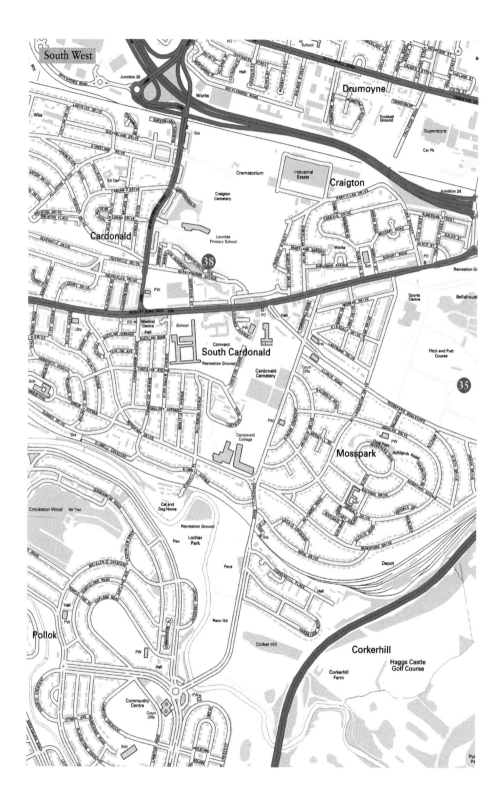

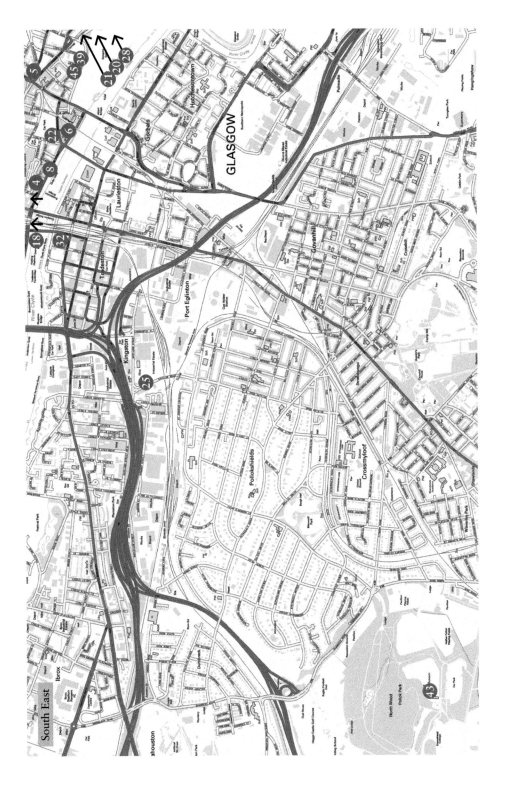

Introduction

Hand in hand with my dad, I would be taken through Glasgow's streets from our home in Anderston to my granny in Bridgeton or to my other granny in the Garngad. Those walks were an education and throughout my dad would point out the buildings, their history and their peculiarities.

More than anything, he instilled in me a love for the history and architecture of Glasgow, an interest that has been amply rewarded since my books have taken me throughout our great city researching and photographing how Glasgow has developed and changed.

I learned about 'Greek' Thomson, whose St Vincent Street church could be seen from our tenement window and its clock kept us on time for school and church. Charles Rennie Mackintosh's iconic art school was just up the road from me and always open for degree shows. Perhaps the greatest joy was that I attended school for two years in what had once been the Martyr's School in Townhead, one of Mackintosh's earliest commissions.

In 1999, Glasgow won the coveted title of UK City of Architecture and Design. By that time we had realised that several terrible mistakes had been made and some lovely buildings had been lost to developers. Nevertheless, the award recognised that Glasgow, despite its harsh image, had always put an emphasis on the purpose of buildings as well as their presentation. While this may have been diminished through war and depression, the idea of buildings for people has always been to the forefront. Critics may argue that some of the buildings were eventually not fit for purpose. That may be true but in many cases Glasgow was simply ahead of its time, allowing experimental architecture and design to flourish.

There are buildings in this volume that are not particularly dramatic in an architectural sense, and may not even be familiar to many, but which, like the Provand's Lordship, are important in the great history of Glasgow's people, religion, trade and industry and its recognised place in the world.

I have also included a few buildings which, like old friends, are no longer with us but were important in their time. They do, however, leave traces that can be followed as you journey through one of Glasgow's greatest assets, its buildings, second only to its people, because as our motto says, 'People Make Glasgow'.

Michael Meighan

The 50 Buildings

Glasgow was established primarily as a centre of worship and pilgrimage to the shrines of St Mungo and St Enoch. The size of Glasgow Cathedral shows the influence and growth of the Catholic Church in Scotland before the Reformation. The cathedral survived only because it was defended by citizens determined to protect it from the Protestant mob. Even back then it was considered to be the finest Scottish building surviving from Glasgow's early days.

The cathedral stands proudly in wide cemetery grounds not at all dominated by its near neighbour the Glasgow Royal Infirmary, or the newer St Mungo Museum of Religious Life and Art. Behind it on a low hill, in Glasgow's Victorian Necropolis are interred many of the eminent Glaswegians of past days.

The accepted tradition is that Christianity first came to Scotland with Ninian, a Briton from the fourth century. Ninian had studied in Rome and became the first Roman Catholic bishop to visit Scotland, establishing a church in Whithorn. The Church wasn't particularly strong between then and AD 563 when the Irish monk Columba and his followers established a monastery on Iona. Monks from there went on to establish communities and monasteries throughout Scotland and Europe.

From these small beginnings, a Catholic church was established in Glasgow around AD 550 by St Kentigern, known in Scotland as 'Mungo' (meaning 'dear one'). Mungo was also the first bishop within the British Kingdom of Strathclyde, based at Dumbarton. The Roman Catholic Church continued to expand in the city as the population grew and as Glasgow grew in importance as a place of pilgrimage to St Mungo and his mother, Thenew (St Enoch).

The first stone cathedral dates from 1136, when it was consecrated in the presence of David I. This building was destroyed by fire. The replacement was consecrated by Bishop Jocelin in 1197. The building was not completed until the time of Bishop William de Bondington, who died in 1258. The tomb of St Mungo is in the crypt underneath.

Glasgow Cathedral is a proud and magnificent example of Scottish Gothic architecture, which flourished from the mid to late medieval period after developing from the Romanesque style. This is often associated with rounded arches, thick walls and small windows, whereas Gothic adopted a more pointed style and used buttresses to support thinner walls that often have large stained glass windows.

When you visit the cathedral you must make time to visit the nearby Necropolis, Museum of Religious Life and of course, the Provand's Lordship and physic garden.

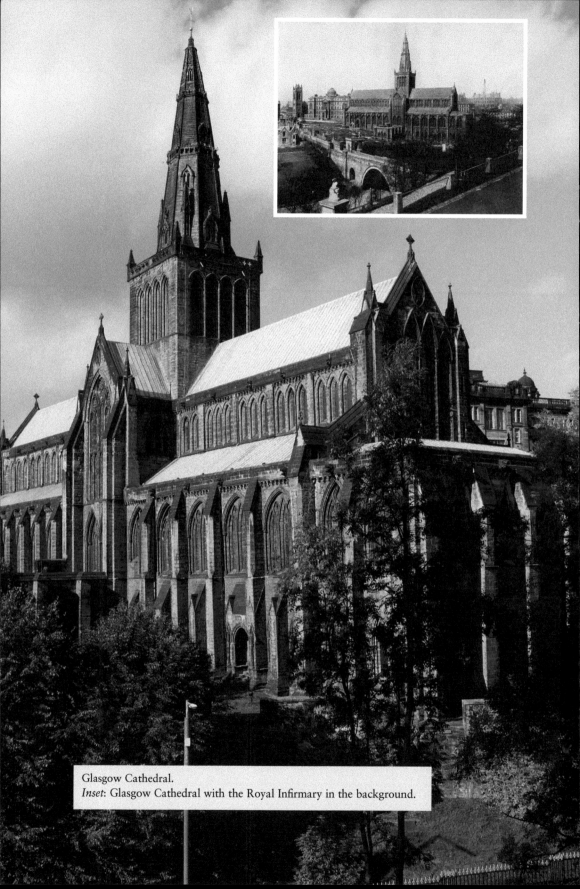

Glasgow Cathedral.
Inset: Glasgow Cathedral with the Royal Infirmary in the background.

2. Old College (c. 1460), High Street, G1 1PH, and Pearce Lodge, University Avenue, G12 8LU

The University of Glasgow was founded in 1451 by a papal bull issued by Pope Nicholas V, at the behest of James II. Teaching at the university began in the crypts of Glasgow Cathedral and the chapter house of the Dominican order of Black Friars before moving to nearby Rottenrow, to a building called the Auld Pedagogy.

Following the 1560 Reformation in Scotland, Mary Queen of Scots gave the university thirteen acres of ground previously belonging to the Black Friars on High Street. Here, using remnants of the friary, including the chapel, the university became established and it was to remain in the area until the buildings were demolished in 1870, making way for the city of Glasgow Union Railway College Goods Yards, when the university moved to Gilmorehill in 1870.

In the seventeenth century the university buildings were rebuilt behind a façade 285 feet long on the east side of High Street. This encompassed an imposing gateway and decorated windows. The date 1658 was carved above the gateway and a slab bearing the date (1660), CR II and the royal coat of arms proclaimed the restoration of the Stuart monarchy and Charles II as king.

The lower entrance to the new university on University Avenue may be familiar to modern day students at the University of Glasgow as the ornate gateway from Old College was incorporated into the university's Pearce Lodge (a gatehouse in University Avenue) when the old buildings were demolished. Sir William Pearce was a shipping magnate and one of the original founders of Fairfield's shipyards. He funded the removal and preservation of the arch.

The Old College both attracted and produced some fine students and lecturers, including Adam Smith, father of modern economics and author of *An Inquiry into the Nature and Causes of the Wealth of Nations* (1776). Joseph Black was a lecturer in chemistry and here he developed his theory of 'latent heat'. James Watt worked at the college as a mathematical instrument maker. Perhaps it was from here that he walked down to Glasgow Green, where it is said that he came up with his ideas for improvements to the steam engine.

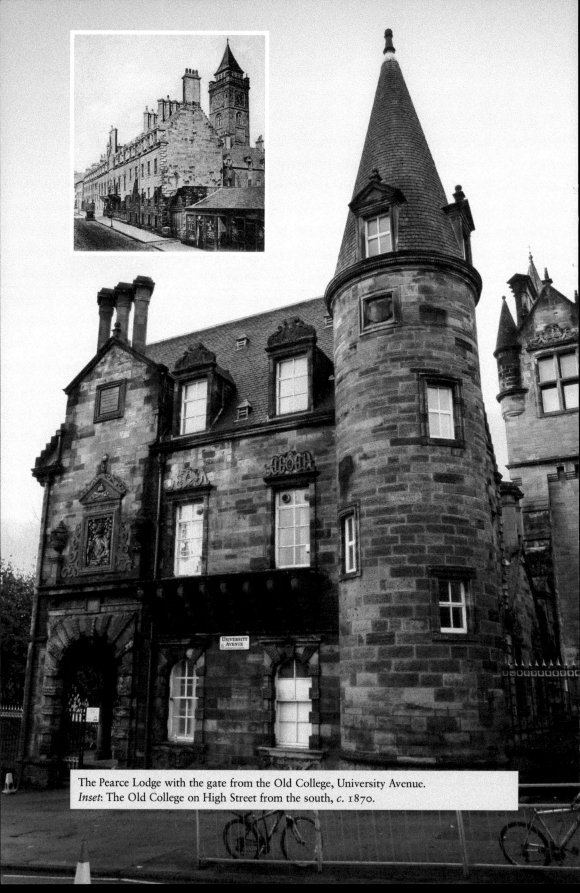

The Pearce Lodge with the gate from the Old College, University Avenue.
Inset: The Old College on High Street from the south, *c.* 1870.

3. The Provand's Lordship and St Nicholas' Garden (1471, 1610), No. 3
Castle Street, G4 0RH

Glasgow's reputation as a centre of medical advances is second to none and it started early. In medieval times, medical treatment was provided by the Church and the only surviving relic of a hospital building is the Provand's Lordship, opposite Glasgow Cathedral. It was built by the bishop of Glasgow, Andrew Muirhead, in 1471 as accommodation for the preceptor (or master) of the nearby St Nicholas Chapel and Hospital. A later part has been dated to 1670.

St Nicholas Hospital was built to house and care for 'a priest and twelve old men'. It may also have been used to house canons (priests) associated with the cathedral. It was in use throughout the 1500s and possibly the 1600s, but was in ruin by 1780.

While the hospital was demolished in 1808, the survival of the preceptor's house is probably because it was constantly in use until the 1800s although descending into neglect because of poor management and uncertainty of ownership. From 1844 it came under the control of Glasgow's Lord Provost and its survival is probably down to prominent Glaswegian physician and magistrate Dr William Gemmell who bequeathed £100 for the upkeep of 'the most ancient existing hospital, the poorest, the most neglected, the veritable Cinderella of hospitals in Glasgow'.

The building was also said to have been the manse of the Canon of the Prebend of Lanarkshire and through this the building became known as Provand's Lordship, a corruption of his full title. A prebendary is a senior priest with an administrative or financial role and there were thirty-two associated with the cathedral. At that time the building may not have been widely known as the Provand's Lordship, but simply as Nos 3–7 Castle Street.

It is known that the first secular use of the building was from 1642 when it was owned by a wealthy textile merchant, William Bryson. It was possibly he who added an internal staircase to the property. Buildings such as these would originally have had wooden outside stairs and possibly wooden balconies. It would also have had multiple occupants.

By 1906 the building was being used as a sweet factory and shop by the Morton family when the Provand's Lordship Society was formed to save it. It was recognised even then that this was an important building and possibly the oldest in Glasgow. The Morton family stayed on until the end of the First World War when the society took full possession of it and it was substantially restored.

The Provand's Lordship continues in use as a museum, with the interior decoration and furniture gifted in 1927 by Sir William Burrell, the shipping magnate who also gave us the Burrell Collection. It was in the early 1960s that I visited it and for a wee lad it seemed quite dull and dusty and not a bit interesting. It was never a popular attraction and Glaswegians rarely visited it. Things have greatly improved now as the tenements around it have gone and the interiors are

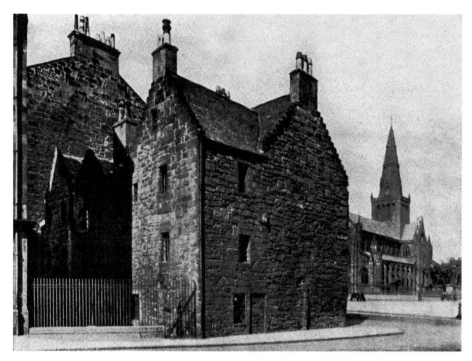

The Provand's Lordship.

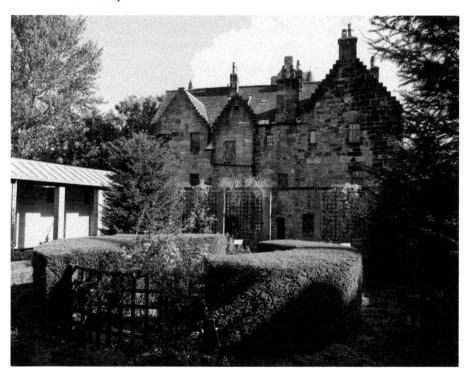

The Provand's Lordship and St Nicholas' Garden.

brighter. Now that you can see them, the stained glass panels are delightful and the historical interpretations very interesting.

The building features 'crow steps', the style from the 1500s onwards that is like a staircase on the gable end of the building; these are common on Scottish buildings of the period and also later. The steeply pitched roof is also a particular feature of Scottish roofs as it helps prevent heavy build-up of snow. Provand's Lordship is a Grade-A listed building.

It is now one of Glasgow's museums and an interpretive display shows how medieval Glasgow may have looked. At the back of the house is St Nicholas' Garden, a medicinal 'physic' garden; while not an original feature, it is supposed that the hospital would have had one. It grows herbs that would have been in common use at the time. The garden is also home to the surviving stone Tontine Faces, which once graced the frontage of the Tontine Hotel at Glasgow Cross.

I said that Provand's Lordship was possibly the oldest building in Glasgow and it has always been considered so. However, there is a counter claim from Provan Hall, further east in Glasgow in Auchinlea Park on the edge of Easterhouse. Provan Hall, believed to have been built about ten years before Provand's Lordship, is one of the best preserved fortified houses in Scotland set in land granted to the church by the Earl of Cumbria, who became David I.

The house was the country home of the same Canon whose town house was the Provand's Lordship. Provan Hall would have been his base for managing the estate. Like the Provand's Lordship, Provan Hall was saved for the nation when it came up for sale in 1934 when the last of the family then owning it died without heir. The hall now belongs to the National Trust for Scotland and is managed by Glasgow City Council.

There is another connection between both buildings. Following the death of James IV the Prebend of Provan passed to the Baillie family. Sir William Baillie was a friend of Mary Queen of Scots and she may have visited Provan Hall and stayed in the Provand's Lordship while her husband Lord Darnley was a patient in St Nicholas Hospital 'suffering from the pox'.

4. The Tron Kirk and Steeple (1525), No. 63 Trongate, G1 5HB

In the early twentieth century the centre of Glasgow was home to over 100 churches of a wide variety of denominations. Many of these have disappeared, some after a second life as warehouses or shops. One remaining and very prominent church is the Tron Kirk in the Trongate.

While the existing church was built in the seventeenth century, there had been a church here dedicated to the Virgin Mary since 1484. This became the collegiate church of St Mary of Loreto and St Anne in 1525, falling into disrepair after the Reformation when the church and its cemetery were sold by the town council.

It was taken over as a Presbyterian church, the 'Laigh Church' or Tron Church around 1592. A tower was added in 1593 and a steeple added a few years later. The

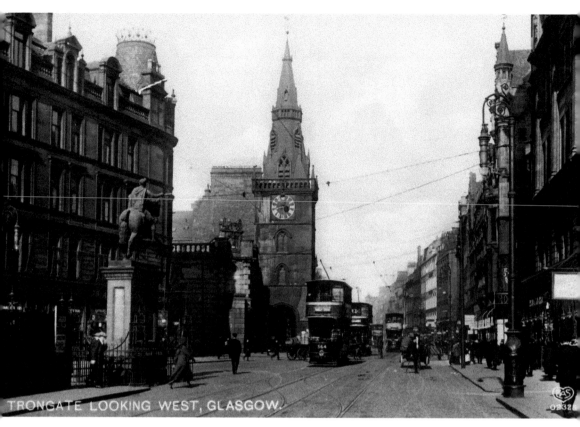

TRONGATE LOOKING WEST, GLASGOW.

An older view of the Tron Kirk and steeple.

tower and steeple were the survivors of a fire that destroyed the church in 1793. It was rebuilt in 1794. The arches at pavement level are actually an addition by Glasgow architect John Carrick in 1855. Old drawings show it without the arches.

When its role as a church ended in 1946, the building was taken over by Glasgow Corporation building department and in 2004 became the Tron Theatre, which has been added to and is now a popular modern theatre, bar and restaurant.

Opposite: The Tron Kirk and steeple.
Opposite inset: The Tron Kirk and steeple today.

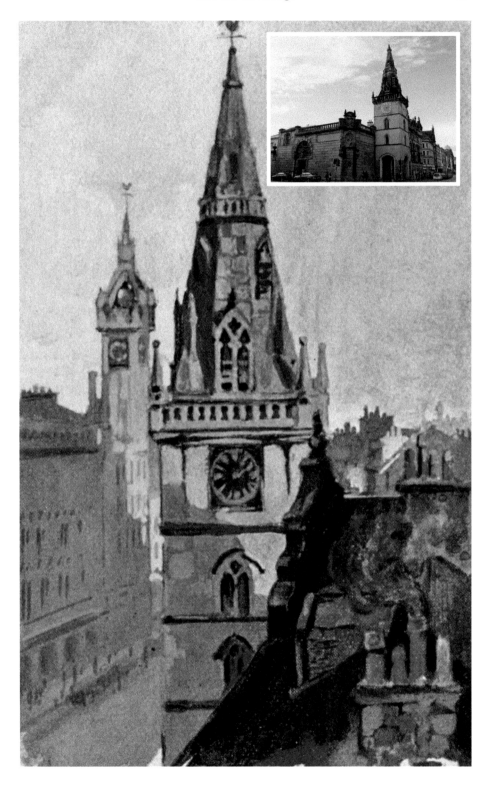

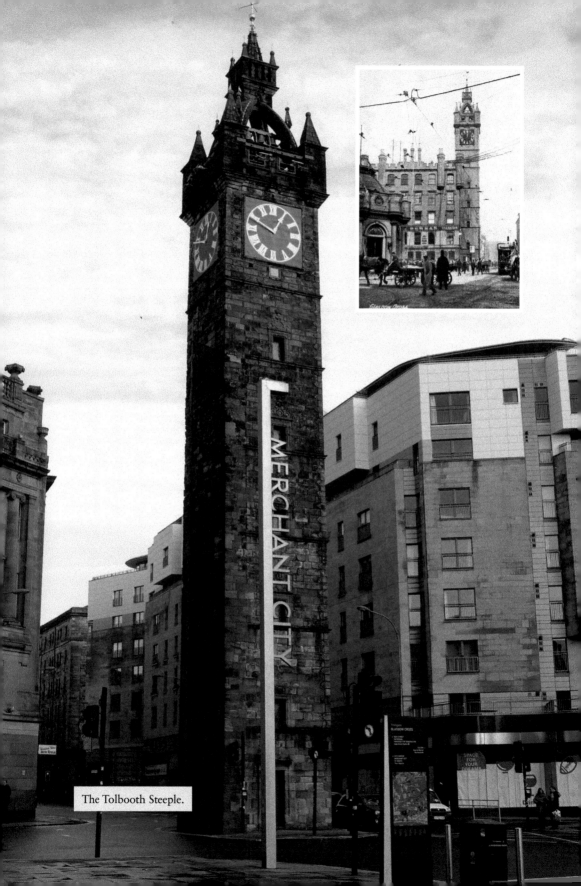

The Tolbooth Steeple.

5. The Tolbooth (1627), High Street, G1 5ET

The surviving seven-storey Tolbooth Steeple is what remains of what was once a prison and city administrative buildings; it's possibly the most well known of Glasgow's landmarks. The Tolbooth was taken down in 1921, leaving the steeple on an island accompanied, as I remember, in the 1960s, by an underground public toilet that has since been removed.

The Tolbooth, or Council Chambers, was at the heart of Glasgow's culture and prosperity. Here, in the Trongate outside the Tolbooth, the Tobacco Lords paraded their wealth in their black silk breeches, three-cornered hats and red jackets, sporting silver and ebony sticks. They would strut about on their own pavement, the Plainstanes, beside where the statue of King William of Orange had originally stood for 160 years before being moved to Cathedral Square in 1923.

From here, proclamations were read and punishment was meted out, including public hangings. Some of the punishments for more minor offences were cruel and even humorous. One involved the perpetrator's ears being pinned to the door of the Tolbooth (lug pinning). However, it attracted so many sightseers, including schoolchildren 'plunking' school and weavers leaving their work, that it was abandoned. In 1814 the council sold the building to move to Jail Square in the Saltmarket, leaving the tower isolated but still central to the city.

6. Merchant's Steeple and the Briggait (1659 and 1665), Merchant Lane, G1 4SP

Since early days the merchants of Glasgow had worked together to further their interests in national and international trade. In 1659 they completed a Merchant's Hall and hospital for old and destitute merchants. The steeple was added in 1665. The steeple is Gothic with a Renaissance balustrade. It is said it was intended for the merchants to their ships returning along the Clyde.

The Merchant's House, as it became known, was an influential body with many ongoing campaigns, including the widening of the Clyde and the protection of its tobacco interests during the American War of Independence in the eighteenth century.

The building, except for the steeple, was taken down in 1818 to make way for tenements. The Merchants moved to a fine new building in George Square, while a new fish market was built around the steeple. The market was designed by Clarke and Bell who, with Alexander Bryden, also designed an extension in 1886.

It has now been converted into artist studios and the steeple restored. There are forty-five studios for artists and five creative shop front units within a restored public area. It is an A-listed building with many original Victorian features, including the iron balconies.

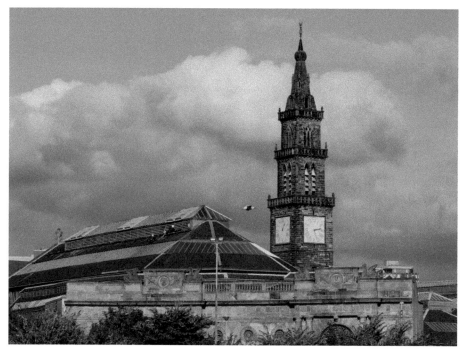

The Merchant's Steeple.

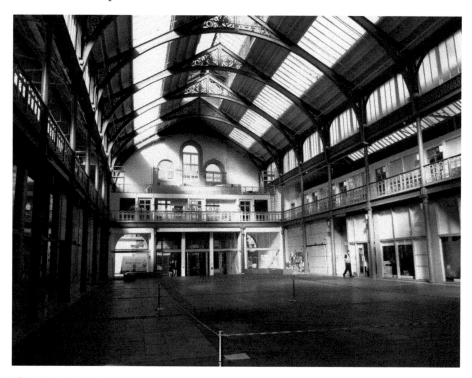

The Briggait interior.

7. William Cunninghame Mansion/Royal Exchange (1778), Royal Exchange
 Square, G1 3AH

At the time of the Roman occupation, Scotland had nothing that could be called a
town. This was true until the twelfth century when chartered towns, or burghs, were
created. Glasgow was made a burgh by King William the Lion in 1175. Archbishop
Jocelin was instrumental in this too, as he also was in establishing a local market
and annual fair in the town with protection for the traders. The trade continued
with the development of specific markets trading in flesh, milk, fruit, vegetables, salt
and fish. This fair was to become the Glasgow holiday, 'Fair Fortnight'.

Crafts developed to service ecclesiastical and trade customers as well as
travellers and pilgrims visiting the cathedral and tombs of Mungo and Enoch.
These included tanners, fullers, weavers and fleshers. There is very little evidence of
dramatic growth of the town or in trade over the centuries. In fact other towns in
Scotland like medieval Roxburgh, Stirling and Perth were all larger trading towns.

While trade from England to Europe and the rest of the world had been
growing over the centuries with the improvement of ships and trading routes,
Scotland had largely been excluded from this. By the late 1600s the country
was in a parlous state. It had no export trade to speak of and had no power to
compete with its neighbour England, to whom, since 1603 it had been joined
through the Union of the Crowns by a common monarch, rather than any

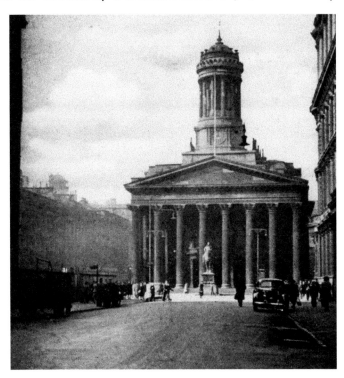

William Cunninghame
Mansion/Royal
Exchange (1778).

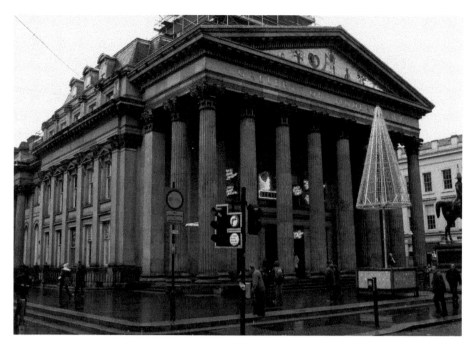

GOMA.

The Tobacco Merchant's House, Miller Street.

economic union. In fact English laws which protected English trade also prevented Scottish traders competing in English markets and in their colonies in North America and the West Indies.

It was the trade in tobacco, sugar, rum and cotton that would catapult the city into a major world trader and the Tobacco Lords were instrumental in this. The Tobacco Lords were mostly a product of the 1707 Treaty of Union, which allowed trade between Scottish merchants and what had been exclusively English colonies. The position of the Clyde also gave it an edge when sailing ships took such a long time to cross the Atlantic. The Firth of Clyde was where the Trade Winds first hit Europe and this gave up to three weeks time advantage.

The merchants had also developed and built large ships specifically for the American tobacco trade and had built personal networks in the New World, particularly in Virginia on the east coast. They also managed the intake of the crop and warehousing so that ships would turn around quickly. The Navigation Acts, which had previously acted against Scottish interests, now allowed Scotland to benefit. In addition, in 1747 they managed to negotiate an agreement with France as the sole importers of tobacco into French territories. By 1760, with tobacco being transshipped from Glasgow to most areas in Europe, the town had outstripped London as the main port for tobacco in Great Britain.

The wealth created by the tobacco merchants is well illustrated by the houses in which they lived. None was as ostentatious as William Cunninghame's mansion in Royal Exchange Square, completed in 1780 by an unknown architect. This was originally on Cow Loan, which Cunninghame renamed Queen Street in honour of Charlotte, the wife of George III.

Retiring to his country estate of Lainshaw, East Ayrshire, Cunninghame sold the building to textile merchant William Stirling, who used it partly as a warehouse. In 1817 it became a branch of the Royal Bank of Scotland. Only ten years later, architect David Hamilton started the conversion to the city's Royal Exchange by the addition of Corinthian columns to the façade as well as a tall cupola and an extensive newsroom. In 1844 the present statue of the Duke of Wellington was erected in front of the building.

The building served as a business centre where deals were done and it was here that the first telephone exchange was established in 1880. In 1949 the building was taken over by Glasgow Corporation and it housed Stirling's Library until 1969 when it became the Gallery of Modern Art, or GOMA.

Even when I was a little boy, people thought it great fun to stick cigarette ends into the fingers of the soldiers on the bronze frieze below Wellington's statue. I don't know when it became a custom to cap Wellington with a traffic cone but it has now become an established Glasgow icon even though 'the powers' have tried to stop it for 'health and safety reasons'.

While visiting the GOMA, you might have a look at the Tobacco Merchant's House close by in Miller Street. The building probably gives a more realistic idea of the kind of mansions occupied by the merchants. It was restored by the Glasgow Building Preservation Trust, whose home it is now.

8. St Andrew's Metropolitan Cathedral (1816), No. 90 Dunlop Street, G1 4ER

We have seen that Glasgow was established primarily as a centre of Roman Catholic worship and pilgrimage to the shrines of St Mungo and St Enoch. The size of Glasgow Cathedral shows the influence and growth of the Catholic Church before the Scottish Reformation in Scotland.

The Roman Catholic Church continued to expand in the city as the population grew and as the cathedral grew in importance as a place of pilgrimage to St Mungo. The convent of the Franciscans (Grey Friars) arrived to set up a chapel around 1475, with one to the Virgin Mary dedicated in 1477. They remained in the area until the Reformation and the buildings were probably destroyed around 1566. Following Catholic emancipation in 1829, they were the first to return to Glasgow in 1868 with a mission in the Calton. They also established a parish in the Gorbals that same year and they prospered, with a new chapel being built in 1881.

Meanwhile, north of the river the burgeoning Catholic population (many were immigrant Catholics from Ireland or the west of Scotland) did not have a place to worship. In 1805 there were around 450 Catholics in the city, but by 1814 numbers had risen to 3,000. A decision was taken to build a church in Clyde Street on land bought from the trading company of Bogle and Scott. The church of Saint Andrew, designed by James Gillespie Graham, was completed in 1816 and it signalled the formal reintroduction of the Roman Catholic Church to Glasgow.

The neo-Gothic, or Gothic Revival, church is modest for a cathedral, mostly because Catholics were keeping a low profile as there were restrictions on the building of Catholic churches. While there were some freedoms from the late 1700s, these restrictions weren't fully lifted until the Catholic Relief Act of 1829.

St Andrew's Cathedral and diocesan offices.

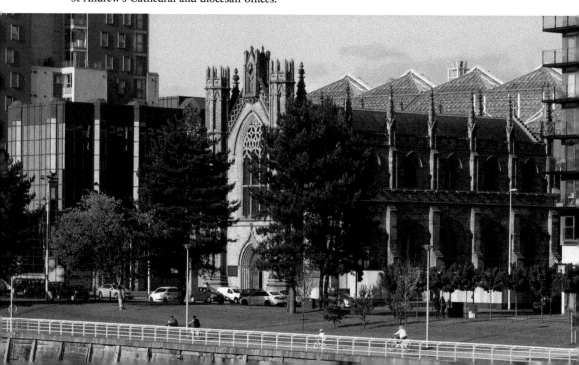

There was a great deal of hostility towards the new church: while the building went up during the day, vandals wrecked the work in the night. Guards had to be posted and congregations from other religious denominations helped out with the costs to show solidarity.

In 1884 the church was raised to the status of pro-cathedral and renovated by Pugin and Pugin. A pro-cathedral is a parish church that serves as a cathedral.

As the riverfront developed, the cathedral was surrounded by industrial buildings and tenements, many of them in a very sad state of repair. It has only been in recent times that St Andrew's has seen some space to breathe and let light into the buildings.

Now, the reflected light of its modern diocesan offices allows the cathedral some breathing space. Also adjoining the cathedral there is now a cloister garden commemorating Catholic Italians who perished in the sinking of the *Arandora Star*, which was transporting German and Italian detainees to Canada.

9. Speirs Wharf Port Dundas (1851), Speirs Wharf Port Dundas, G4 9TB

On Speirs Wharf were the offices of the Forth & Clyde Navigation Co. and the City of Glasgow grain mills and stores built for John Currie & Co. in 1851. The buildings were converted in 1989 into 150 loft-style residential apartments, a private leisure centre, and nineteen commercial units.

We have already talked about the opening up of the Clyde and growth of shipping on the river. Almost as important in opening up of trade to Europe and the Baltic was the opening of the Forth and Clyde Canal, once called The Great Canal.

Speirs Wharf.

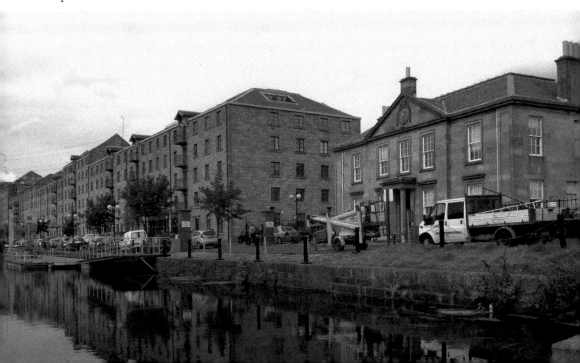

With the close proximity of ironstone and coal, the birth of Scotland's iron and steel industry had begun in 1759 at the Carron Iron Works in the east and there emerged an urgency to move this heavy product to the west. The need to join east and west coasts produced what was Scotland's largest civil engineering project to date. When it opened in 1790 it was quickly being used to transport over three million tons of goods each year.

The canal also produced an impetus to growth, encouraging the building of factories, breweries, distilleries and foundries. Besides iron coming to the foundries in the west, firebricks came from G. R. Stein's works at Manuel, once the largest maker of the fireclay brick in the Empire, and which was to be so important in the manufacture of steel.

The Forth and Clyde Canal Co. was incorporated under a 1768 Act of Parliament as The Company of Proprietors of the Forth and Clyde Navigation. It was finally opened in 1790 having suffered a hiatus for several years from 1775 due to lack of money. It was resurrected with the help of government funds, much of it from estates confiscated from the defeated Jacobites after the Battle of Culloden in 1746.

The canal was a highly successful enterprise. Not only did it allow for the transportation of iron, ironstone and coal to the works and factories in the west but it allowed those on the east to trade with Ireland and beyond. A major advantage was the fact that vessels could head for the Atlantic via the canal and not go round the south coast. In time of war this was a hazardous journey, with ships sometimes having to travel in convoy and with high insurance premiums because of the danger of attack from French ships during the Napoleonic Wars.

The best alignment of the canal took it north of the city through Bishopbriggs, Maryhill, Anniesland and Clydebank finally joining the Clyde at Bowling. In order to bring the canal into the city centre as well as connect with the previously isolated Monkland Canal, a spur was built from Maryhill to Port Dundas.

Port Dundas was to quickly become a major industrial area hosting the famous, now closed, White Horse Distillery as well as chemical factories, textile mills and glass and pottery works. It was also the site of the Pinkston Power Station that was built in 1900 to provide electricity for the newly electrified Glasgow Corporation tramways.

The Monklands Canal was first opened to bring coal from the Lanarkshire coalfields, but as the nineteenth century wore on and as the Lanarkshire steelworks developed, the canal played an ever more important part in transporting steel, iron and finished goods to Glasgow and the Clyde.

With the coming of the railways, both canals became a second transport option and began to lose profit. The Forth and Clyde was taken over by the Caledonian Railway who didn't have a great deal of interest in making it competitive. It fell into disuse as trains and lorries began to transport heavy goods.

Now, with a £94 million grant from the Millennium Commission, the Forth and Clyde Canal has been reopened. Bridges and locks have been replaced and once

again boats ply their way. The banks now provide fine walking and I have even seen fishing. The canal is now a major tourist attraction and central to that is the Falkirk Wheel and the Kelpies sculptures, near to where the Carron Ironworks once stood.

1C. Gardner's Warehouse (1856), No. 36 Jamaica Street, G1 4QD

Gardner's warehouse finds its place in this book because this 1856 wonder is the oldest commercial building with a cast iron façade in Great Britain. It is considered to be a landmark in architecture as it was the first to apply the processes and materials of London's 1851 Crystal Palace to commercial architecture.

The building was designed by John Baird and the iron frame by Robert McConnell, ironfounder, who owned the patent for the malleable iron that was used in the construction. This was not Baird's first venture with iron as he had already glazed the roof of the nearby Argyle Arcade with the same material, but the Iron Warehouse was a bold adventure in the way in which Glasgow designers were to become known for experimentation and innovation.

The clever design of Gardner's has the window panels shrinking in height at each succeeding level while the arches become more rounded. The overall effect is of a light and airy building. Many other buildings of cast iron were to follow but rarely did they make as much prominent use of the material.

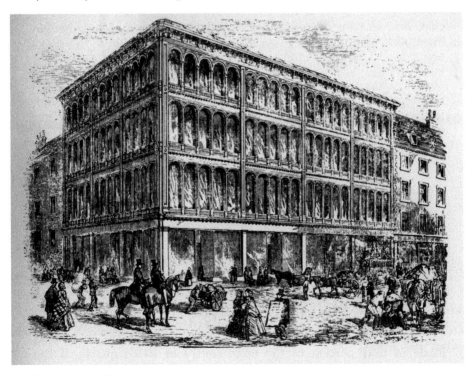

Gardner's 'Iron Building'.

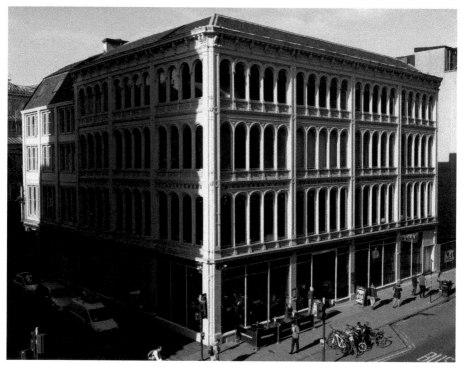

Gardner's Warehouse.

The façades on both Jamaica and Midland Street are entirely of cast iron and glass plate, giving a symmetrical and elegant finish that enhanced the display of furniture in Gardner's warehouse. Gardner, established in 1832 was a well-known furniture maker which was taken over by Martin and Frost in 1985.

Now the building has been taken over by JD Wetherspoon and named 'The Crystal Palace'. It is still a graceful building and another fine example of sensitive restoration. It is worthy of a visit, particularly to see the original Otis elevator, imported from New York in the 1850s.

11. Kelvinside Free Church/Òran Mór (1858), Byres Road, G12 8QX

This is what we call in Glasgow 'gallus'. A difficult term to describe, but the cheeky halo round the steeple of Òran Mór is certainly gallus. This building is in the book as a representative of the dozens, if not hundreds, of churches closed over the years. For a previous book I made a rough count that in the area between Byres Road, Kelvingrove Park, the Clyde and Central Station there were around sixty churches and ex-churches of a wide variety of denominations. These were not all because of falling attendances. Many of these were due to the schisms that racked the Established Church of Scotland and its derivatives ever since the Reformation.

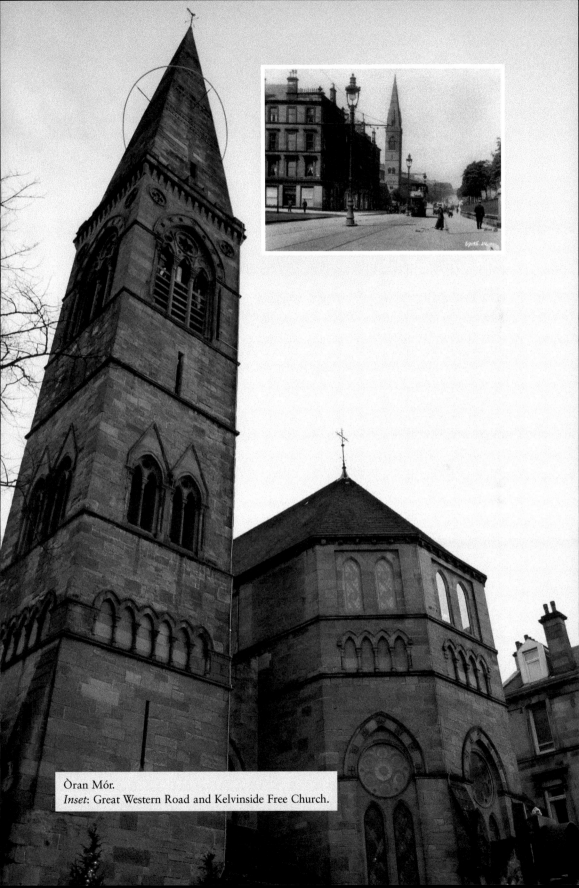

Òran Mór.
Inset: Great Western Road and Kelvinside Free Church.

If you were an architect of the correct persuasion and you weren't too adventurous during those days then your future in church building was assured. Much of that fine architecture has disappeared along with some fine stained glass and sculpture.

Many of these churches throughout the city disappeared under new housing and offices. Some have become flats, furniture or carpet showrooms, music venues and recording studios. One or two have become theatres and that takes me to the Kelvinside Free Church at the junction of Byres Road and Great Western Road. This church was the inspiration of the Glasgow publisher John Blackie Snr who foresaw the need for a place of worship for those who were moving into new developments in what is now called the West End.

In its new incarnation, Òran Mór has been taken to the heart of the West End and indeed, has a central part in the West End Festival. With the interiors still retaining original features it is a delightful and relaxing place. It is a popular bar, often visited by myself and friends and I have also attended Òran Mór's own *A Play, A Pie and A Pint* which offers one hour plays, changing each week, in its very own theatre and now in other venues in Scotland.

The church was originally constructed in the Gothic Revival style in 1862 by J. J. Stevenson of Campbell Douglas and Stevenson. In 1909 after the congregation had become 'United Free', alterations were carried out by John Keppie of Honeyman, Keppie and Mackintosh.

Internally, cast iron columns support delicate arches that are adorned with the sculpted heads of famous churchmen. These were the work of William Mossman.

It is now a B-listed building. It stands opposite the Botanic Gardens with its marvellous Kibble Palace. You might also have a look at two other Glasgow treasures just behind the church: the Botanic Gardens Garage and the former Hillhead Picture Salon. The Garage is the only surviving public parking garage in Scotland and the latter, one of Glasgow's first suburban cinemas, now a bar and restaurant.

12. St Vincent Street United Presbyterian Church (1859), No. 265 St Vincent Street, G2 7LQ

I have chosen the St Vincent Street United Presbyterian (UP) Church to represent Alexander 'Greek' Thomson, Glasgow's second best known architect. At least he is now, having been neglected for so long. As a young boy in Glasgow, I knew about Thomson from my father, but precious few knew about his contributions to Glasgow's skyline. He was a pioneer in sustainable building and wrote regularly in the international architectural press. However, locally his architectural contribution was generally disregarded.

It is such a pity that the sandstone used in the church was not able to weather Glasgow's unkind industrial climate during the nineteenth and twentieth centuries. It is still an amazing structure, which has seen a fair amount of internal restoration. The embellishments on Thomson's buildings clearly show the reason

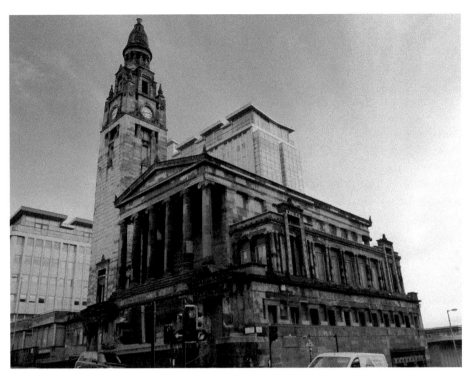

St Vincent Street United Presbyterian Church.

Grecian Chambers, Sauchiehall Street.

for the 'Greek'. In fact they are more than Greek as they variously show pre-Roman influences from Greece, Egypt and from India. Thomson's three Glasgow churches are neoclassical in that they adopt the principles of classical antiquity, the Palladian columns of Andrea Paladio (an Italian architect) being a major feature.

Much of the sculptural work is by John Mossman and internal decoration was carried out by Daniel Cottier whose work can be seen in the Cottier Theatre, the former Dowanhill Church.

The church was built in 1859 for the Gordon Street United Presbyterian (UP) Church congregation. The site on Gordon Street was bought by Thomson and his brother George where they built a warehouse, which became known as the Grosvenor Building. The Grosvenor was designed by him as a commercial enterprise with his brother. Unfortunately the building burned down just after completion. It was rebuilt between 1864 and 1866. It hasn't had a happy history though: it caught fire again in 1901 and was rebuilt in 1907 as The Grosvenor Restaurant to the original style by Clarke, Bell & Craigie. It blazed again in 1967 and was once again reinstated but this time to offices.

With the profits from the sale of the Gordon Street church, the UP congregation built their St Vincent Street church. The congregation was dissolved in 1934 and had it not been taken over by the Glasgow Association of Spiritualists, it may have had the same fate as Thomson's other UP church in Caledonia Road which stands now as a protected ruin. In the 1960s, the building was saved by its sale to the City Council and it is now leased to the Free Church of Scotland.

Thomson's reputation now flourishes alongside Mackintosh, but not before the destruction of some of his buildings. The classical Queen's Park United Presbyterian Church was destroyed by a wartime incendiary bomb and the shell only remains of the Caledonian Road United Presbyterian Church. Both of these are in the monumental classical style favoured by the United Presbyterian Church.

Fortunately there are a number of residential properties still to be seen and these include a lovely crescent in Langside as well as Holmwood House in Netherlee. This villa is Thomson's finest domestic building, built for the Glasgow businessman James Couper. Holmwood is now managed by the National Trust for Scotland and is really worth a visit.

Symmetry is the mark of Thomson's commercial buildings and can be seen clearly here as well as in his Grecian Chambers on Sauchiehall Street. These should also be in your visit as should the Grosvenor building and the nearby Egyptian Chambers on Renfield Street, which are in a sorry state.

13. University of Glasgow Gilmorehill (1870), No. 9 University Ave, G12 8QQ

We have seen how the beginnings of university education in Glasgow was in the Old College in High Street and how it eventually moved out of those fine buildings to make way for industrial progress.

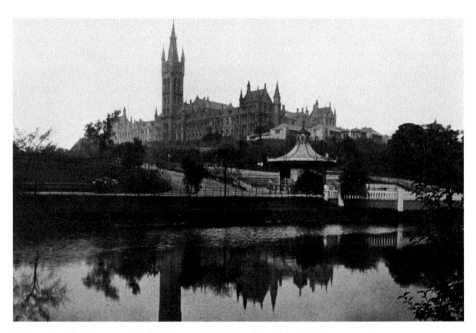

University of Glasgow with Kelvingrove Park bandstand in the foreground.

The Gilmorehill building was designed by Sir George Gilbert Scott. It is the second largest example of a Gothic Revival building in Great Britain after the Palace of Westminster. The university (with the purchase of many Victorian buildings) now straddles most of Hillhead and has a campus at Garscube in the North of Glasgow, which houses the veterinary school and research facilities in the College of Medical, Veterinary and Life Sciences.

The university is now among the highest in world rankings and derives a great deal of its funding from research grants for those among the top performers in the field. This is well illustrated by some of those who were to graduate from, or teach, in the institution and who were to establish its place as one of Europe's great centres of learning.

One of the most famous was Lord Kelvin who is generally acknowledged as the father of modern physics. It was Kelvin who turned this very small 'natural philosophy' department into a large and effective department teaching physics. It was an educational example to the rest of the world. He was also instrumental in turning inventions into practicalities, taking out about seventy patents.

Born as William Thomson in Belfast, 1824, he was to move to Glasgow at an early age when his mathematician father took up a post at the university. He was well provided for and his father ensured an excellent start to his career with introductions allowing him to study at Peterhouse College, Cambridge where he excelled in all subjects, including sports. However, his main interests were in physics, particularly in the fields of thermodynamics and electricity.

He introduced the absolute scale of temperature, now measured in 'Kelvins'. He was a prodigious researcher and produced around 600 papers. He successfully

introduced a range of nautical instruments including depth sounders, compasses, sextants and chronometers. His work has been extremely important to science and to Scotland and reflects why we have been so successful in the application of scientific discovery. He was an entrepreneur who could see practical application in his work and through this contributed considerably to Britain's ability to defend itself through two wars.

Other teachers and students include Adam Smith, economist and author of *The Wealth of Nations*; John Logie Baird who pioneered television; R. D Laing, the author of *Sanity, Madness and The Family*, who is noted for his work on mental illness; John Grierson, the 'father' of the documentary and famous for *Drifters* and *The Night Mail*.

The University of Glasgow continues its growth with the planned redevelopment of Kelvin Hall. The changes will see the world-famous University Hunterian Museum installed in the building, making this area a destination for museum and art gallery visitors from home and abroad. The building will also incorporate the National Libraries of Scotland Scottish Screen and Sound Archives. The Royal Highland Fusiliers Museum will also be hosted there, as will contemporary and fine art galleries.

14. St Andrew's Halls (1877), Granville Street, G3 7DN

It seems that Glasgow has always needed bigger and better concert halls if the new SSE Hydro is anything to go by. This was as true in the 1870s when the city needed a new venue in the grand and expanding West End. So it was that St Andrew's Halls was opened at Charing Cross in 1877.

The halls, designed by James Sellars were resplendent with sculptures by John Mossman and William Mossman and lamp standards by Walter Macfarlane's Saracen foundry. Sellers was heavily influenced by 'Greek' Thomson and this can be seen in the classical monumental style featuring the high statues. Macfarlanes iron is not surprising as Sellers also designed much of the cast iron output of bandstands and drinking fountains. Sellers was also responsible for the much-loved ornate French-Gothic Stewart Memorial Fountain in Kelvingrove Park.

One of its most popular guests was the famous Glasgow Orpheus Choir, conducted by Hugh Roberton, which played to packed houses. Emmeline Parkhurst was arrested there during a demonstration in 1913. David Lloyd-George also spoke there as did Winston Churchill, Anthony Eden Bonar Law and the queen. Bob Hope entertained there as did I. Embarrassingly, at a very tender age I was on stage there dressed as a girl in the Glasgow Scout Gang Show chorus singing the recently popular 'Walking my baby back home' made popular by Nat King Cole and Johnny Ray in the early 1950s.

The building was almost completely destroyed by fire in 1962. Fortunately the ornate façade in Granville Street was saved and incorporated into an extension to the Mitchell Library.

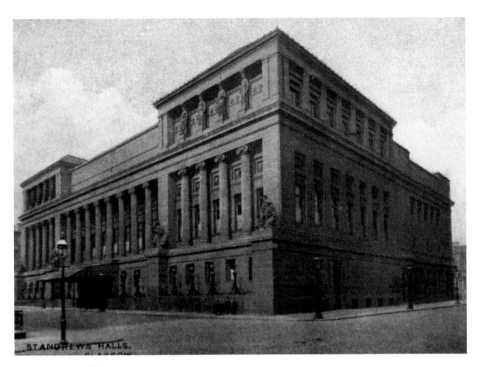

St Andrew's Halls.

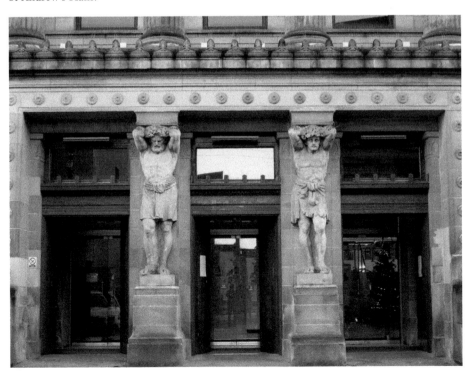

Entrance to the St Andrew's Halls with William Mossman statues.

15. Western Infirmary (1874), Dumbarton Rd, G11 6NT

Glasgow's reputation for advances in medical treatment is second to none and we have seen how that great tradition started with St Nicholas' Hospital. Although the Royal Infirmary dates from 1794, I have chosen John Burnet's 1874 Western Infirmary to represent this great tradition.

In medieval towns, lepers were banished outwith the city walls. The same was true of Glasgow, where the Church owned 'Lands of the Gorbals' housed those suffering from leprosy. Leprosy was then an incurable disease of the nerves and respiratory tracts, spread by contact, particularly nasal droplets.

A leper hospital was built in the Gorbals in the 1300s and was still operating around 1600. This was in Brigend, a bridge over the Clyde having existed since around 1285. This was around where the Citizens Theatre now stands. The hospital was dedicated to St Ninian and became St Ninian's Croft, later incorporated into Hutchesontown, in the Gorbals.

Besides the above, there is very little evidence of the existence of hospitals in Glasgow at the time of the Black Death (a combination of plagues) when it reached Scotland in 1350. Plague is a deadly infectious disease, mostly transmitted by rodents and fleas, and by air contact. In the close-built houses in cramped towns and cities, outbreaks of the disease travelled quickly, bringing a swift death with bodies often covered in pustulating sores.

We can assume that there would have been medical provision of some sort when the plague struck the city again in 1646. By this time, being after the Reformation, there would have been none of the traditional Church treatment available. With each recurrence of the plague Glasgow survived, but with a depleted population.

It was the swift growth of Glasgow that was to bring constant threat of disease. The cramped, overcrowded conditions in which new arrivals were expected to live were perfect for transmission of infection. But hospitals for medical treatment alone

The Western Infirmary.

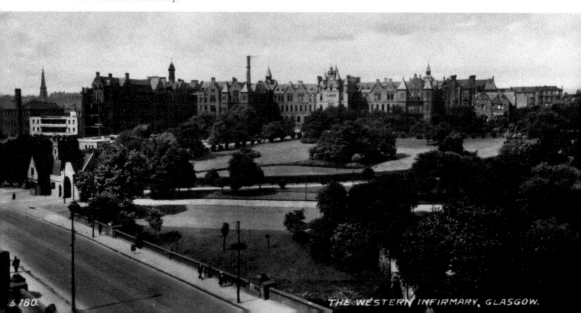

THE WESTERN INFIRMARY, GLASGOW.

seem to have been a novel concept: the town's hospital, opened in 1740 on the banks of the Clyde, was also a poorhouse, a workhouse and a home for the aged and infirm, for orphans and an asylum. This was eventually to become a teaching hospital and from around this time hospitals began to develop as the city grew in all directions.

With the university's move to Gilmorehill in the 1870s, the Western Infirmary was built as a teaching hospital in 1874. The hospital has seen a steady growth since then, helped by my occasional visits for treatment. A fond memory of a tetanus jag in the bum still remains.

Originally with 150 beds this had increased to 600 by 1910, with a surgical department opening in 1936. Like other hospitals it was a 'voluntary' hospital funded by public subscription, which was the case until it was taken over by the NHS in 1948.

But times move on and with the development and rationalisation of hospital services, the facilities at the Western are moving to the new Gartnavel General Hospital and others. The Western is being taken over and redeveloped by the University of Glasgow. That may see some of the removal of the additional buildings that have hidden this fine structure.

There should also be a mention for the war hospitals. As Britain prepared for war, there was no doubt that there would be casualties. To treat the injuries sustained in the coming conflict, a number of emergency hospitals were built round Glasgow. One of these was at Killearn, near Drymen. Being near to the Clyde and Clydebank, the hospital was used to treat seamen arriving from convoys and those injured in the Clydebank Blitz, as well as prisoners and war workers.

Killearn Hospital was associated with the Western Infirmary and had its own specialities, including orthopaedic and neurosurgical units. I visited a relative there many times in the 1960s and I can confirm the difficulties in getting there by public transport, which was one of the reasons for its closure in the 1970s. Strangely enough, the buildings are still there, abandoned, and give some idea of what a wartime temporary hospital looked like.

16. The Pumphouse, Queen's Dock (1877), No. 100 Stobcross Road, G3 8QQ

The Pumphouse was, and continues as, a familiar landmark to those sailing up and down the Clyde. It was first built in 1877 to provide hydraulic power to the bridge spanning the Queen's Dock as well as dock cranes and capstans.

With the death of river trade and removal of the bridge, the building went into disuse but was resurrected as an Indian and then an Italian restaurant, the latter very appropriate given the Italianate style of the building. The campanile, or bell tower, did have a function as it was a hydraulic accumulator that was disguised very effectively. The building was commissioned by the Clyde Navigation Trust and is the work of city architect John Carrick and John Burnet (senior).

In yet another incarnation, plans are now underway for the building to house a new whisky distillery and visitor centre.

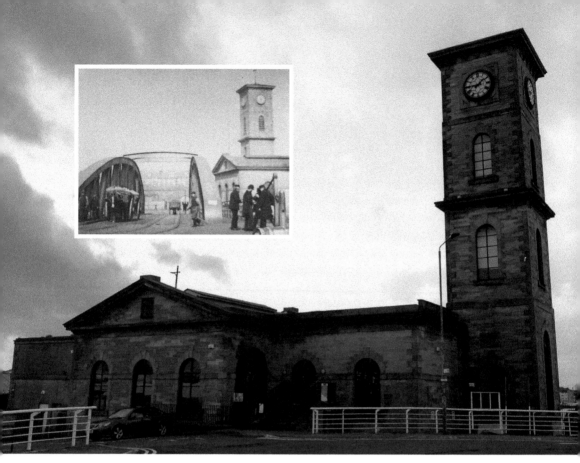

The Pumphouse.
Inset: The Pumphouse, Queen's Dock.

17. Grand Hotel Charing Cross (1882), Charing Cross, G3 7UJ

As a representative of the fine buildings that disappeared as a direct result of the building of the new M8, I give you one of Glasgow's favourite hotels; located in an area with as fine period architecture that you would find anywhere in Great Britain. It was built in 1882 and while it may not have been the most outstanding building of the time, its major advantage, and its downfall, was its prized detached and prominent position. This gave it prestige and, as a result, it was one of the most photographed of Glasgow's buildings, appearing against the still remaining Charing Cross mansions and beside the Cameron Memorial Fountain, itself a Glasgow landmark.

The Grand was designed by the Baird and Thomson practice. By this time Baird had died and the practice carried on by James Thomson, a prolific architect with buildings throughout Scotland.

While the Grand has gone, some of the fine buildings still stand, including John James Burnet's Charing Cross mansions. Burnet was responsible for many of Glasgow's fine buildings. The Glasgow Savings Bank (now Jigsaw, a shop in Ingram Street) is an example of his decorative style.

Grand Hotel and Charing Cross.

Charing Cross Mansions.

18. Clyde Navigation Trust (1886), No. 16 Robertson Street, G2 8DS

Ever since I was a wee boy walking along the Broomielaw I have been impressed by the magnificent Clyde Navigation Trust building at the foot of Robertson Street. It is one of the Clyde's most spectacular landmarks. The building was another of Glasgow architect J. J. Burnet's designs, embellished by the sculptural work of Glasgow's John Mossman. His work includes figures of Father Clyde on his throne with Poseidon and Triton in attendance. Following the death of Mossman and for the second phase of the building, the figures of James Watt, Thomas Telford and Henry Bell were sculpted by Albert Hodge. These are on the Robertson Street face of the building and high up on the corner. Framing the cupola are the huge sculptures of Poseidon's wife Amphirite leading seahorses. On the left of the dome a bull is being led by Demeter, the goddess of the harvest.

It is a wonderfully interesting building mixing baroque, Renaissance and Beaux Arts. It is one of J. J. Burnett's earliest works but we don't see it in its full glory. The corner section was intended to be the centrepiece of a much larger work that was never realised. Difficulties in obtaining the land to fulfil the huge ambition to rival the city chambers prevented it. So did the First World War, when work had to stop.

In 1759 an Act of Parliament gave powers to Glasgow town councilors 'to cleanse, scour, straighten and improve' the River Clyde between Glasgow Bridge and the Dumbuck Ford near Dumbarton. From that time, continuous improvements including the building of numerous groynes or jetties from the banks straightened and deepened the river.

Many of the river developments on the River Clyde would never have been accomplished without the cooperation of the Glasgow merchants. They worked

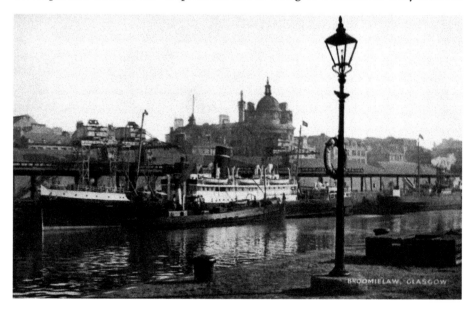

Clyde Navigation Trust building.

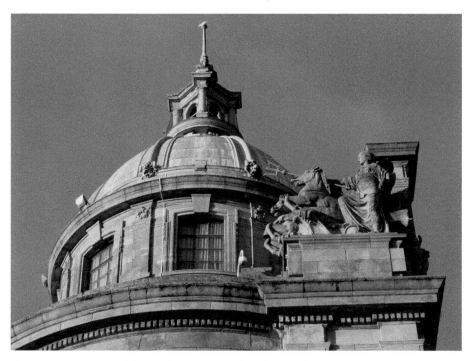

Cupola and sculpture of Amphitrite and horses by Albert Hodge.

with the Glasgow Council to manage the affairs of the Clyde and in 1858, separating the affairs of town and river, the council left the arrangement and the Clyde Navigation Trust was established. The Trust's representation included traders, ship owners and builders, industrialists, council representatives, Merchant's Hall and Trades Hall.

With trade disappearing from the river, the role of the Trust also diminished and in 1966 it was replaced by the Clyde Port Authority, but still in the same building.

19. Glasgow City Chambers (1888), George Square, G2 1DU

British civic architecture came into its own during the Victorian age when councils (most of them made up of prominent businessmen) saw the need to prove their superiority in commercial and civic duties through the building of grand city chambers. Throughout Great Britain councils erected ostentatious piles that they thought represented their worth and dignity.

This was also true in Scottish cities and there is none grander than the Beaux Arts Glasgow City Chambers. The design for the chambers was chosen in a competition, won by Paisley Architect William Young, and constructed between 1882 and 1888. Young began his career in Scotland, but moved to England and practised in Manchester and London, where his most prominent other work is the War Office on Pall Mall.

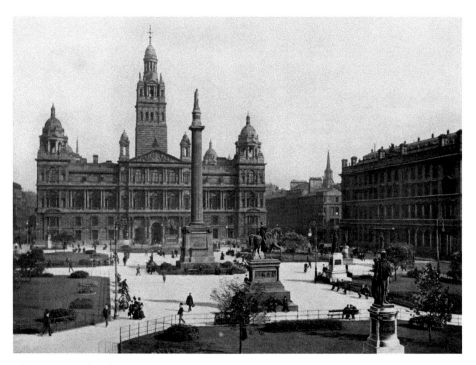

Glasgow City Chambers.

The building also incorporates Italianate styles and a wealth of decoration and statutory displaying Glasgow's position as second city of the Empire and its dealings throughout the globe. The first few feet of the building are of polished Aberdeen granite. On the north and west the sandstone façades are from Polmaise and on the south and east, from Dunmore, quarries in Stirlingshire.

The sculptures are the work of many artists, known and unknown. The classical friezes adorning the façades of the Chambers are the work of George Anderson Lawson, well known for his 1892 monument to Robert Burns in Ayr. Other contributors include J. and G. Mossman, Edward Good and Charles Grassby.

The interior of the building is no less sumptuous than the exterior. Polished granite and Carrara marble interiors are enhanced by gold leaf ceilings, stained glass and rich mahogany walls. I attended a presentation in that very same great banqueting hall where Nelson Mandela received the Freedom of the City in 1993.

20. Templeton's Carpet Factory (1892), No. 62 Templeton Street, G40 1DA

There can hardly be a Glaswegian who doesn't know about Templeton's carpet factory on the Glasgow Green. James Templeton, its founder, was a Highlander from Campbeltown in Argyll, who along with many thousands of his ilk, left the poverty of the Highlands and Islands to find fame and fortune in Glasgow.

By the time he was twenty-seven James had set up a business in Paisley making shawls, and with William Quiglay worked on a patent for the machinery for 'a

new and improved mode of manufacturing silk, woollen, cotton and linen fabrics'. Buying out Quiglay he was joined by his brother in-law and moved to King Street in the Bridgeton area of Glasgow to expand his business. Production started in 1839 and by 1851 the company was employing 400 people. By the start of the First World War it was reputed to be the biggest carpet manufacturer in the United Kingdom. By the 1950s it was Glasgow's biggest employer with 7,000 workers in this and other mills in the area.

It is said that the nearby residents in Monteith Row, then a very desirable area, objected to Templeton's building plans for a new factory a number of times so he was forced to come up with a dramatic design which would guarantee acceptance. He recruited architect William Leiper who emulated the Doge's Palace in Venice to produce what must be one of the most unusual industrial buildings in Europe. Leiper is also known for Glasgow's Gothic Dowanhill Church, now home of the Cottier Theatre. Its opening in 1889 was tinged with sadness, as soon after, a freak gust of wind combined with alleged bad building work caused a partial collapse of a the main façade, killing twenty-nine workers. It was rebuilt and reopened in 1891.

At the end of the 1960s, the Guthrie Corporation, a rubber plantation owner, was looking for a foothold in the British flooring market. They succeeded with

Templeton's carpet factory.
Inset: Templeton's carpet factory detail.

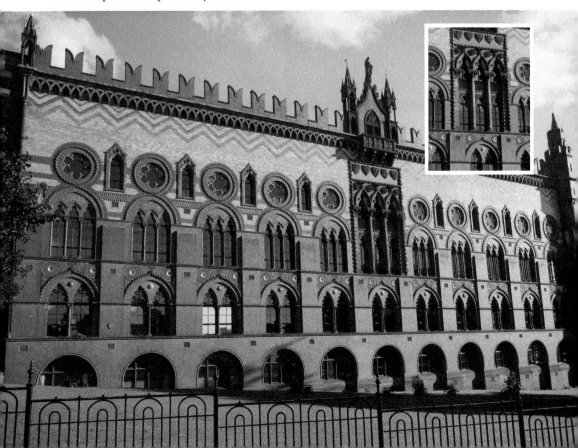

a takeover of Templeton's in 1969. Guthrie was ambitious and in 1980 they acquired a £1.5 million stake in Stoddards. It subsequently closed down the Templeton factory and transferred production to the Stoddard mill in Elderslie.

The redundant building was reopened as a business centre in the 1980s with architect James Anderson winning the Regeneration of Scotland Design Awards. It now also houses a popular microbrewery and bar.

It is well worth a visit, as is the People's Palace and Winter Garden and the restored Doulton fountain. A stone in Glasgow Green also commemorates the place where James Watt was said to have come up with his ideas for a condenser for the steam engine so starting the age of steam and allowing the power loom to produce carpets at Templeton.

21. The People's Palace and Winter Gardens (1898), Glasgow Green, G40 1AT

As a child, I was taken by the hand by my father round the People's Palace. Then, the Palace, like many museums, was a dusty mausoleum of stuffy old artefacts locked up in glass cases. The only thing of interest was an orrery, a huge brass model of the solar system contained in a glass dome around six feet high. The whole piece, with planets suspended on wires, would move through night and day when a brass handle was inserted into a slot in the side and turned.

The museum now reflects Glasgow's social and industrial past in interactive and very interesting exhibits: Glasgow in wartime, the cinema, Red Clydeside and Glasgow fashion.

I am a regular visitor to the People's Palace and have been over many years – ever since I was a little boy and my Auntie Katie would take photos of us in the Winter Palace, the huge glasshouses attached to the back of the Palace. The Winter Gardens house a collection of exotic plants but also a popular café, which is well used by East Enders and sometimes features art and other exhibitions.

The People's Palace and Winter Gardens was opened in 1898 by Lord Roseberry, who said this was 'A palace of pleasure and imagination around which the people may place their affections and which may give them a home on which their memory may rest'. He declared the building 'Open to the people for ever and ever'.

The red sandstone building is in a Renaissance style. William Brown Whitie was the main architect although this appears to have been under the control of City Surveyor Alexander Beith McDonald who had been responsible for many municipal projects, particularly under the City Improvement Scheme.

The Winter Gardens, with their extensively glazed panels and foliage draped paths, make this a delight to walk or sit in. I wonder what the air quality might have been like when it was built. While it is set in the expansive Glasgow Green it would still have been in the middle of one of Glasgow's busiest and dirtiest areas. Now though, 100 years after its opening, the Palace was given a new lease of life with a £1.2 million restoration. With a redeveloped Green and against the backdrop of the Doge's Palace and with the newly restored Doulton fountain, it is a joy to visit.

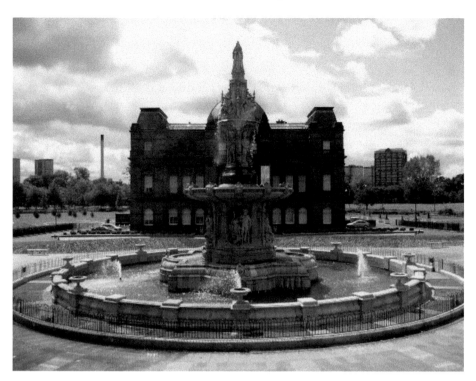

The People's Palace and the restored Doulton Fountain.

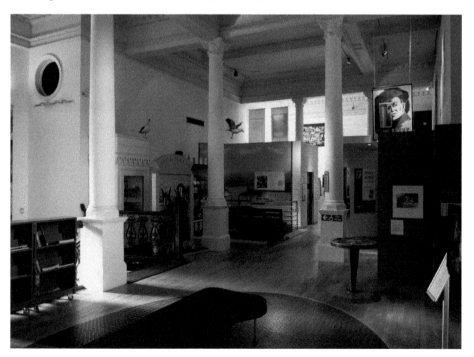

Inside the People's Palace.

22. Hampden Park (1903), Mount Florida, G42 9BA

Glasgow has the honour of having hosted the world's oldest international football competition. Played in 1872, this was between Scotland and England and, strange as it may seem, it was played on the grounds of the West of Scotland Cricket Club in Hamilton Crescent. The game was a 0-0 draw.

The SFA, formed soon after in 1873, is still the governing body of the game in Scotland. For many years it was based above Kelvingrove Park in Park Gardens but it is now housed in the rebuilt national stadium at Hampden Park.

While it is home to many international games as well as pop concerts, the stadium actually belongs to Queen's Park Football Club and it is also the home of the modern 'round ball game'.

Queen's Park was a highly successful club, attracting audiences of up to 10,000. Their success created some great football history as Glasgow and Scotland took to the 'gemme'. Their home ground took its name from Hampden Terrace, which overlooked their first ground that they occupied for ten years, beginning with a Scottish Cup match in 1873. It hosted the first Scottish Cup Final in 1874, with Queen's Park beating Clydesdale 2-0. The Scotland versus England match followed in 1878, with Scotland beating England 7-2.

With continuing success, a new stadium was built in 1884 at Crosshill and the Hampden name carried with it. This was later to become home to another famous club, Third Lanark, later renamed Cathkin Park.

Queen's Park laid the foundations of modern team play, 'the scientific game', rather than the individual approaches that they had up to that date. It was also decided that their motto would be '*Ludere causa ludendi*' ('To play for the sake of playing'). That amateur status has been upheld till this day and makes the club unique in senior football.

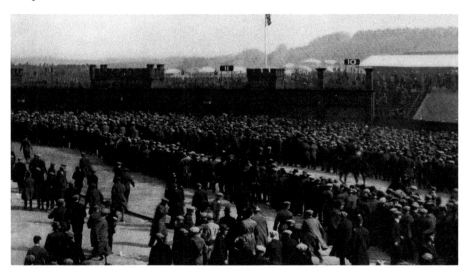

Hampden Park *c.* 1933.

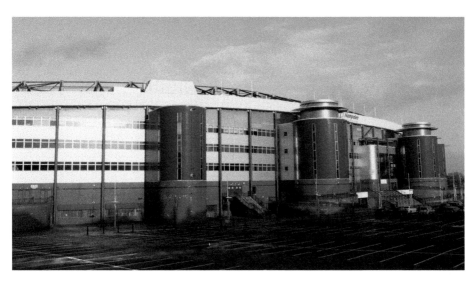

Hampden Park in 2015.

They were also the instigators of the Scottish Football Association when they wrote to the early teams in 1873. There was a response from eight clubs: Clydesdale, Vale of Leven, Dumbreck, Third Lanark, Eastern, Granville and Kilmarnock. With Queen's Park, these formed the basis of the SFA. A resolution was passed to set up an association based on the rules of the Football Association (FA), as well as to provide for an annual cup competition.

Following the formation of the SFA, most of the matches played would be 'friendlies', local cup matches or SFA Scottish Cup ties. In England, organised competitive leagues had started to form. The Football League started in 1888 and this included Scottish teams. With the professionalising of football in England, Scottish footballers had been attracted south for the large salaries. The English called these 'Scotch professors' as many of them had university backgrounds; naturally, as the universities were closely associated with the beginnings of Scottish football.

In 1900, a decision was taken to build a new stadium at Mount Florida. The new Hampden Park opened in 1903, becoming the world's largest stadium, until overtaken by Maracanã in Rio de Janeiro in 1950. It was innovative, having a car park, a press box, crush barriers and a tannoy system.

Richard Henderson was involved in the building of the stadium, although it is not clear if he was the original architect. James Miller was certainly involved, working with Glasgow engineer Alexander Blair. Miller was involved in many prominent designs, particularly for the railway companies. Botanic Gardens Station and the gardens entrances would be familiar to many West Enders; the St Enoch Underground Station is also an iconic building.

By 1937, the capacity had been increased to 150,000 and just as well as the record-breaking attendance at the 1937 England versus Scotland was 149,415, still a European record for an international football match. Following safety measures, the capacity was reduced to 81,000 in 1977.

After many years of debate, including an option to close the stadium, the UK government gave a grant of £3.5 million in 1992 and work started. With further funding from the National Lottery, the stadium finally fully reopened in 1999 for the Scottish Cup Final. The reduced capacity is around 51,866.

Since then, Hampden Park has hosted many prestigious events including the 2002 UEFA Champions League Final and games in the 2012 Olympics. It also became an athletics stadium for the 2014 Commonwealth Games. In the future the stadium will host matches in the UEFA Euro 2020 competition.

After many years at Park Circus the stadium is also the home of the SFA as well as the SPFL. It also hosts the excellent Scottish Football Museum and now can be visited any day of the week.

23. Glasgow City Improvement Trust Buildings (1905), No. 153 Stockwell Street, G1 4LR

Daniel Defoe (the author of *Robinson Crusoe*) visited Glasgow in 1707 and had declared it 'the cleanest and beautifullest, and best built city in Britain, London excepted'. By 1807 all this had changed. While there continued to be fine new developments, building in the city was generally uncontrolled, oblivious to sanitary engineering and was outstripping the ability of the fast growing population to be fed and watered.

The huge industrial expansion in Glasgow, aided and abetted by harsh conditions in rural communities, attracted not only Irish but those from the West Highlands and from Lanarkshire and Ayrshire. In 1750 the population was 32,000, rising to 200,000 by 1830 and on its way to a half million by 1870.

This growing population was housed in poorly designed and hastily constructed buildings, which became squalid and overcrowded. This put pressure on the supply of drinking water and foodstuffs. Watercourses and wells became polluted. The city was choking in the thick smog from the vast factories, mills, workshops and foundries.

In these circumstances disease was rampant and infant mortality high. The period also saw rises in crime, drunkenness and juvenile delinquency. It was a situation that, if left to continue, would probably see the city in economic decline and social disaster. This was a time for radical action. One of those who saw the problems and the likely outcomes was John Blackie Jnr. A publisher by trade, he went on to enable huge changes in the city, becoming a respected Lord Provost and churchman.

It was as a politician that John Blackie made his largest and most long lasting contribution to life in Glasgow. He was elected onto Glasgow Town Council in 1857 becoming Lord Provost in 1863. His major work in this time was the 1866 City Improvement Act, which was a major programme of improving life in the squalid poorer areas of the city.

The 1866 Act gave Glasgow Town Council powers to set up a City Improvement Trust. This was to purchase slum property, demolish it and to widen and realign

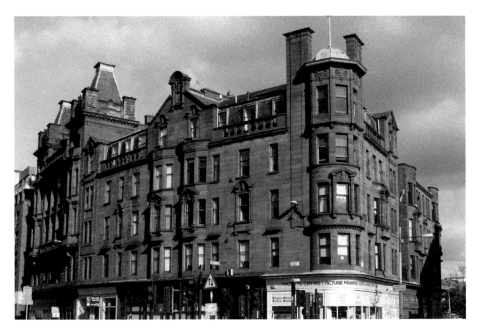

City Improvement Trust Buildings, Saltmarket.

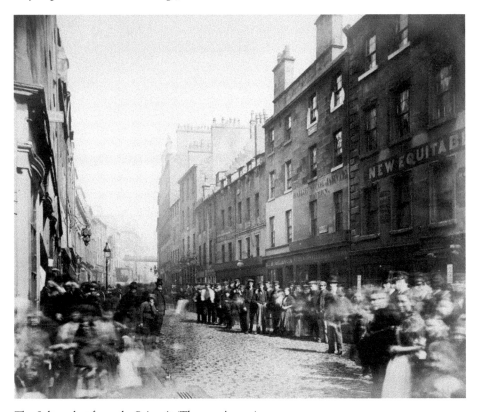

The Saltmarket from the Briggait (Thomas Annan).

narrow city centre streets. The act was also responsible for a new Cleansing Department. The areas targeted for slum clearance were mainly round about Glasgow Cross. The idea was to demolish the outdated buildings of the time, widen roads and then encourage private builders to build on the cleared areas. Restrictions were imposed however, such as limiting the buildings to four storeys. There was to be only one single apartment in each level, with the remainder to be two or three room apartments.

However, building on the cleared land was very slow, partly caused by the collapse of the City of Glasgow Bank and the recession at the time. At one time the Improvement Trust had to cease demolishing properties and found itself Glasgow's biggest slum landlord. It wasn't until the 1890s that building got going again: soon the trust had built thirty-four tenements containing 1,200 homes. For example, Howard Street was built with sixteen single room houses and thirty-two, two-room apartments. By 1913, the Corporation, which took over responsibility for housing from the Trust, had built 2,199 tenement houses in the city.

The construction of single and double room apartments for whole families may seem very mean to us today and perhaps reflects the standards of what was being replaced.

As a representative of the buildings put up by the Trust, I have chosen those at the corner of Stockwell Street and the Briggait (just around the corner from the tenements in Thomas Annan's photo). The buildings were supposed to shine in excellence and throughout the area up to the cathedral, down the Saltmarket and beyond, you will see magnificent red sandstone buildings embellished with carvings, cupola, bay or oriel windows, ionic columns, balustrades and any other architectural features that you might elegantly include. They are mostly tasteful and include many of those Edwardian delights that we have come to know as 'The Glasgow Style'. You may see this style of building throughout the city and often, as in Hillhead, with delightful leaded windows and stained or engraved glass doors.

These were completed by Alexander Beith McDonald as City Surveyor for the Office of Public Works. No doubt with a large staff, McDonald was prodigious at this time. His other works include many that I visited, including the Stobcross and the Kennedy Street public baths as well as the 1912 reconstruction of the McLellan Galleries in Sauchiehall Street.

As a precursor to the city developments, photographer Thomas Annan was recruited to record life in the city tenements. The image here shows exactly the same place before the redevelopment.

24. Glasgow Central Station and Caledonian Railway Buildings (1883–1906), Gordon Street, G1 3SL

It may seem strange that while Glasgow Central Station is now Glasgow's main railway terminal, but it was not always so. Until the Central and the now demolished

St Enoch were opened, Glasgow's main terminal for southern trains was at Bridge Street, on the other bank of the river.

Bridge Street Station had been the terminal of the Glasgow and Paisley Joint Railway and opened for traffic in 1840. It quickly became popular, particularly for those passengers used to the much longer steamer journeys from the Broomielaw down the River Clyde and west coast to Ayr and beyond.

While we are familiar today with the plethora of different operating companies, it was much the same in the early days before the grouping of railways under the Railways Act of 1921 and eventual nationalisation under the Transport Act of 1947.

Bridge Street station had been jointly managed by the Glasgow, Paisley, Kilmarnock and Ayrshire (GPK&AR), and the Glasgow Paisley and Greenock (GP&G) Railway. The GPK&AR merged with the Glasgow, Dumfries and Carlisle Railway to form the Glasgow and South Western Railway (G&SWR) in 1850. This became part of the LMS in 1923. The GP&G became part of the Caledonian Railway in 1847, which in turn was also to become part of LMS in 1923.

For thirty years the station served both the Caledonian Railway and the Glasgow and South Western Railway well. However, both companies wanted to get across the river and into the heart of the city.

In 1870, it was the Glasgow and South Western that was to be first over the river on the still existing bridge, but not to St Enoch, their eventual terminus. Given the difficulties they had in securing properties on the north bank, they decided to build a temporary station in Dunlop Street. This was used from 1870 until 1876, closing on the day that St Enoch's station opened. The hotel was to open three years later.

You would have thought it sensible for competing railway 'operating companies' to collaborate on both a crossing and a terminal, but it was not to be. There had been a certain amount of acrimony in jointly operating Bridge Street and this carried on. The 'Caley' thought that the G&SWR wanted too much for use of the station so they decided to build their own with plans drawn up in 1866 for a station at Gordon Street in the heart of the city.

But it was not until August 1879 that trains finally departed the platforms at Gordon Street, which was to become Central Station. This was after the completion of the station buildings and the construction of the bridge over the Clyde designed by Blyth and Cunningham and built by Sir William Arrol.

After only a few years, the demands on the station were greater than expected. By widening the station and installing a ninth platform a solution was found. It was only temporary though because the station was soon congested once again. The demand for passenger traffic was booming and more dramatic measures were needed.

From 1899 to 1905 the station was substantially extended to give thirteen platforms. The new work was designed by the architect J. Miller and engineer Donald Mathieson, with the steelwork being erected by the Motherwell Bridge and Engineering Co. This resulted in the familiar façade in Hope Street along with new platforms extending over Argyle Street served by an additional bridge

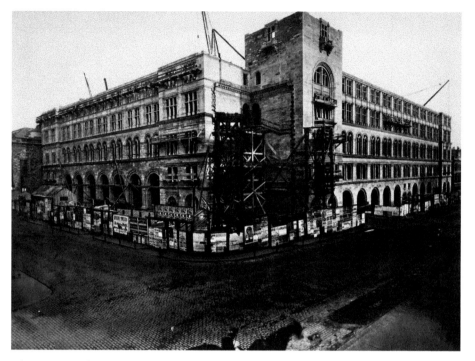

Glasgow Central Station and Caledonian Railway Buildings on Gordon Street and Hope Street, 1905 (Blyth and Blyth).

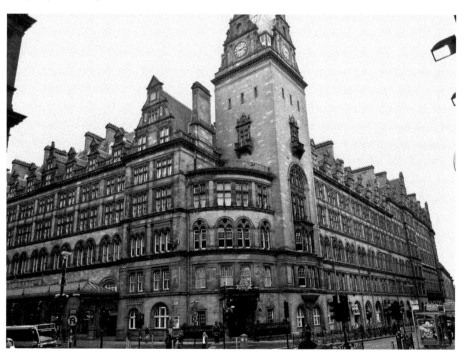

Central Station and Grand Central Hotel.

over the Clyde. At the same time, the Central Hotel was extended and a new office block, designed by J. Miller, was built in Union Street.

From then, Glasgow Central Station remained mostly unaltered until its part renovation in the 1980s. The ticket office moved to a new travel centre next to the Gordon Street entrance and a new electro-mechanical destination board appeared above the platform entrances. The building hosting the destination boards and booking offices became shops with a bar and restaurant upstairs. The floor was covered with terrazzo tiles.

A new five year renovation programme started in 1998 with the biggest alteration to date. The station was completely re-roofed and the building cleaned. Around 2005, a new LED destination board appeared. Further platform improvements have been made and automatic ticket barriers have been installed on most platforms.

The regeneration work on the station earned the prestigious Europa Nostra European Cultural Heritage Award for its architects, Gordon Murray and Alan Dunlop, and builders Arup Scotland, 'Awarded for the research and exemplary conservation of an important nineteenth-century train station, including important protection measures to the roof, executed with sensitivity and meticulous attention to detail.'

25. Scotland Street School (1906), No. 225 Scotland Street, G5 8QB

Scotland Street School is one of only two schools designed by Charles Rennie Mackintosh. The other was Martyr's Public School in Townhead, which I attended when it had become an annexe to my own school.

There are many influences at work here. The symmetrical red sandstone building features twin towers reminiscent of the Scottish baronial style and also looks forward to the tower of the Luma building in Shieldhall, which has a very functional purpose of testing light bulbs. Mackintosh's towers, besides housing stairways, provide illumination throughout the front of the building. Bear in mind that when built, it would have been surrounded by tall warehouses, factories and tenements.

In fact, Mackintosh's towers, the expanse of windows and the layering effect of the top floors on the outside sides of the towers, bring a lot of light into this building. The expanse of the rear playground, separating the building as it does from other buildings, also allows an enormous amount of light into the building.

If you go behind into the large playground, the rear of the building is a bit of a surprise as, from a distance it might be taken as a textile mill with its wide expanse of high windows, no doubt intended to maximise the light coming in. However, even here he has embellished the plain elevations with designs at both ends and a 'tree of life' centre. In fact, up close, the rear is a delightful display of Mackintosh's love of emblems, which sit well on this building.

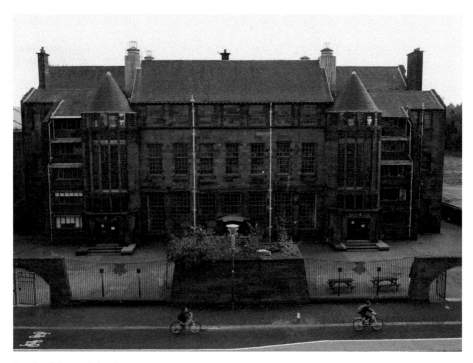

Scotland Street School.

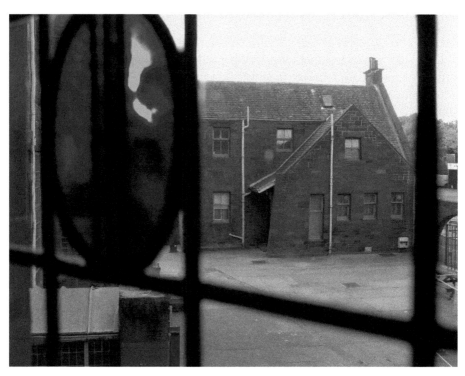

Scotland Street School – the janitor's house from the window.

Scotland Street shows how far Mackintosh had come since his early days of involvement with the design of the Martyr's School as an assistant in the practice of Honeyman and Keppie. Martyr's School shows Mackintosh in the detail, particularly in the art nouveau doorways and decorated rooftop ventilators. The main entrance hallway, with its arched windows and doorways, was used as a gymnasium with bars round the walls. Its wooden floor and tiled walls have been exposed, showing the hallway and central atrium with balconied galleries giving access to the classrooms. I can confirm that the classrooms were indeed light and airy.

It wouldn't be a Mackintosh without the use of emblems, such as the coloured medallions set into the tower windows. Outside, the arched entrances, railings with motifs and the wall decoration are delightful. The janitor's house in the corner of the complex shows Mackintosh's attention to completeness. This house would not be out of place standing on its own in a suburban garden. It is made less ordinary by Mackintosh's asymmetrical swept design, use of the lean-to effect and the contrasting window heights.

26. Kelvingrove Art Gallery and Museum (1901), Argyle Street, G3 8AG

Glasgow was, and is, an industrial city, and it is to this we return to discover the origins of Glasgow as a city of art for the people. Glasgow can be marked among the best cities in Europe for public art displayed on some of its great buildings; even before coming a capital of culture it was named, in 1999, City of Architecture and Design.

The Kelvingrove Art Gallery and Museum became the home of Glasgow art and is still enormously popular with the Glaswegian and the visitor. It received partial funding in 1888 and was to be built as the Palace of Arts for the 1901 Glasgow International Exhibition. The Spanish baroque sandstone building heavily featured architectural sculpture. One myth that surrounds the galleries is that it was built back to front and the architect committed suicide when he realised his mistake. Well, actually, the galleries were always intended to point towards Kelvingrove Park, which is where most of the exhibition was held. The galleries were the work of Sir John W. Simpson and E. J. Milner Allen, who ran a very successful practice that lasted for many more years.

While my best memories of the galleries were the vast number of ship models representing the output of the shipyards, the galleries also host a huge collection of fine art, including old masters, Impressionists, as well as those of the Glasgow School. The ship models have now moved to the wonderful new Riverside Museum, leaving space in the newly restored and enlarged Kelvingrove for the widest range of artworks, as well as a world renowned collection of arms and armour.

The investment in the culture of the city of Glasgow has been impressive and was rewarded by it becoming the European City of Culture in 1990. The Glasgow Art Gallery in Kelvingrove has recently been renovated and tastefully extended.

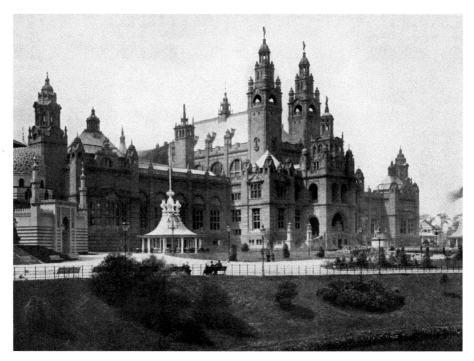

Kelvingrove Art Gallery and Museum.

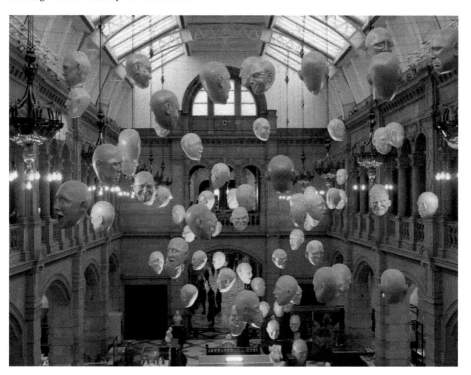

Kelvingrove Art Gallery and Museum.

It is truly wonderful and deserves its position as one of Europe's most visited attractions, many of whom were Glaswegians. While the Kelvingrove Art Gallery and Museum was opened in 1901, in my youth and infancy it was dull and a bit intimidating to a wee boy like me, but it was on my patch and therefore fair game for a visit. However, I do remember being taken by the scruff of the neck by a blue coated attendant and placed in the confines of an office until the police were called. And all for going round and round the swinging doors. Who could resist? I was then ejected when it was felt that I had suffered enough. They obviously stretched the truth when they said the police had been called.

Anyway, exciting changes to the gallery started in 1952 with the exceedingly brave decision of Tom Honeyman to purchase Salvador Dali's painting *Christ of St John of the Cross* for the enormous sum of £8,200. This was to prove controversial because of its religious connotations and in 1961 it was attacked and damaged by a maniac. It was repaired and now takes pride of place in its own special gallery.

Tom Honeyman was the director of the gallery at the time and brought to it a wealth of experience in the private art world, as well as an adventurous spirit that didn't always sit well with his political masters at Glasgow Corporation. His friendship with Salvador Dali brought Glasgow not only the painting, but the copyright, and sales of the image has paid for the painting many times over as well as being a huge draw to the galleries.

27. The Mitchell Library (1911), North Street, G3 7DN

I don't know how many times I must have passed the bust ensconced in its niche in the entrance hall to the Mitchell Library on North Street, the very same street of my childhood. I visited the Mitchell often to read the great volumes of back issues of *The Sunday Post* containing the *Broons* and *Oor Wullie*. Later I was to study there in the great central reading room among the dozens of pupils and students.

To generations of studying Glaswegians, the Mitchell Library is a friendly face and a place of learning and support. Before the expansion of the Glasgow universities and colleges, the Mitchell was the place to study when no space could be found at home. The library is now busy once again, not just for lending, but also for family research, internet access, or to pore over its extensive collection of newspaper archives, for 'The Mitchell' is still the largest municipal lending library in Europe.

Stephen Mitchell is probably one of the best known of a few Scottish tobacco merchants who were to expand their businesses into cigarette manufacturing. Their companies were eventually consumed by growing conglomerates and, like other manufacturing enterprises, lost to Scotland.

Stephen Mitchell was not a well-publicised man: very little is known about him and his lonely death from a fall in his retirement town of Moffat. Mitchell had been born in Linlithgow in 1789, where his family had been involved in

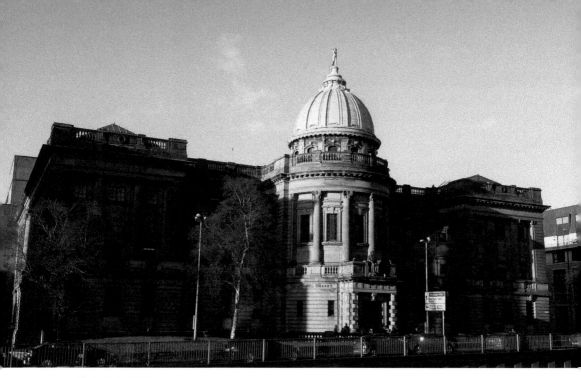

The Mitchell Library.

the tobacco business. In 1825 import legislation, requiring the use of bonded warehouses in designated ports, had taken his company to a base in St Andrew's Square in Glasgow's Gallowgate.

The company continued to flourish; it was taken over by his brother and then his nephew, also a Stephen. Mitchell remained unmarried and retired to Floral Cottage in the spa town of Moffat. Unfortunately he was found dead with head injuries, presumably through a fall on a walk to a local mineral well. Mitchell left an astonishing legacy: not only had he made money from cigarette manufacture, he had invested in railways in Britain and in North America. His will provided bequests to charitable organisations and to the Unitarian Church in Glasgow. The largest, however, was the huge gift of £70,000 for the endowment of a large public library. This was gratefully accepted by the city council and so was established perhaps the greatest public library of its time, which has provided lasting benefits to the city.

Mitchell's other legacy was, of course, the establishment of a cigarette manufacturing industry, which was sold to W. D. and H. O. Wills in 1901 and eventually passed on to Imperial Tobacco. Mitchell represented a tradition of tobacco trading and manufacturing in Scotland that had started with the 'tobacco lords' of the eighteenth century. They had made fortunes in the trade between the New World and Great Britain and are remembered in some street names in Glasgow's Merchant City, such as Virginia, Jamaica, Dunlop and Buchanan Streets. Mitchell is also representative of the merchants and business leaders whose philanthropy was to furnish Glasgow with libraries, galleries and hospitals

that may have otherwise been impossible. Besides Mitchell, these philanthropists included Elder, Burrell, McLellan and Lipton.

The design for the Edwardian baroque building, which opened in 1911, was the result of an architectural competition assessed by John Keppie and won by William B. Whitie. On the library's beautiful copper dome sits a statue entitled *Literature* and is said to be Minerva, the Roman goddess of wisdom. Edwardian baroque is derived from eighteenth century French architecture and from England's Sir Christopher Wren.

When the old St Andrew's Halls adjoining the Mitchell were destroyed by fire in 1962, the only silver lining was that it allowed the Mitchell to expand into a new building that was built within the shell of the old halls.

28. The Olympia Theatre of Varieties (1911), Bridgeton Cross, G40 2QH

Just look at the impressive solidity of the modernised Olympia Theatre, which has just undergone an extensive restoration programme converting it to a modern office block, community centre and library. On a prominent site, it is magnificent in red sandstone. It was built by Thaw and Campbell in their earlier days of a very productive career, which included major work on the new Scottish office buildings on Calton Hill, Edinburgh.

The exterior was designed by the Scottish architects George Arthur and Son, and the interior by specialist theatre designer, Frank Matcham. The theatre opened in 1911. Here, sometime between the opening and 1913, the billboards show *Sleeping Beauty* supported by The Empire Girls.

Following the First World War, the theatre included films on its programme and became a cinema in 1924. In the midst of the boom in cinema attendance, the theatre was acquired by Associated British Cinemas and its interior completely reconstructed. This meant the disappearance of Frank Matcham's lavish baroque interior and a new art deco style replaced it by Charles J. McNair and Henry F. Elder.

In 1974, in the face of falling audiences who were now watching television, the cinema (now renamed the ABC) closed its doors. It had further use as a bingo hall and a furniture salesroom before abandonment and dereliction set in. In 2004 a fire partially destroyed the building.

The Olympia has now been redeveloped and has resumed its place at the heart of Bridgeton. The auditorium has gone and been replaced by four new floors, but it retains the Grade-B façade and has a replaced rotunda. On the ground floor is the new Bridgeton Library.

Another building of architectural importance in Bridgeton is the bandstand constructed by George Smith and Co. of the Sun Foundry in Kennedy Street. The bandstand has recently been restored with Ballantine's of Bo'ness as principal metalwork consultant. It is now back to its nineteenth-century classical glory.

The Olympia Theatre of Varieties, *c.* 1913.

The Olympia Building today.

29. Knightswood Estate (1926), G13

Historical interpretation might suggest that Glasgow's local government had shown little interest in housing matters. It is far from the case. Ever since it found that it was inadvertently the largest slum landlord in Glasgow, it attempted to do something about it, even before the 'slum clearances' of the sixties. The problem was that wars and other events got in the way.

Naturally there was no house building during the First World War. Following the war, rather than returning to a 'land fit for heroes', the soldiers instead returned to unemployment and 'the dole'.

However, Glasgow City Council took the brave initiative to build and they did this with a vision that our people would live in the 'garden city' conditions that had been piloted in England by the likes of Joseph Rowntree in Bourneville and in Welwyn Garden City. Based on the ideas of Sir Ebenezer Howard and Raymond Unwin, houses would be airy, light and have gardens large enough for vegetable plots. The idea was that such areas would be self-contained with their own facilities, such as shops and offices. I can verify all of this as I grew up in Knightswood in a semi-detached house that had been built between the wars.

In 1919, government legislation made it compulsory for local authorities to plan housing schemes and gave out funding for this purpose; with it, Glasgow took this movement to heart and in Mosspark created the first garden suburb, with two-thirds of its population housed in cottage-type buildings.

In Knightswood one of Britain's largest such garden areas was created. From 1923, the city's direct labour squad built 6,714 houses. At the same time, they catered for almost all denominations and eight churches were built, along with

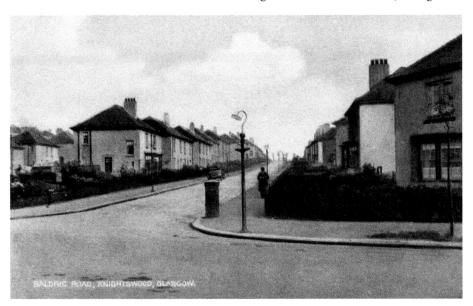

Hermitage Avenue, Knightswood.

Lincoln Avenue high-rise flats.

shopping centres, a nine-hole golf course, tennis courts and football pitches. Even a cricket pitch was provided. It was also a 'dry' area, that is, with no public houses; this is still generally the case.

The houses shown are typical of the earlier buildings. There was a general move away from stone to brick-built and harled construction. The longevity of these buildings is proof of their quality. As part of Glasgow City Council's housing stock, they have been brought up to current modern standards on at least two occasions. Ironically, many of those bought under 'right to buy' show signs of wear and the differences are testimonial to how well councils actually looked after housing stock.

There were accusations of social engineering in that these new houses were designed for the better off professional or skilled workers; it may have been the case that poorer people were excluded as there was no 'points system' like today's to allocate council houses.

Even as these garden suburbs were being created, they were becoming too expensive and by 1926 the standard had to be lowered. The differences in density and quality of build can be seen clearly between Knightswood and Upper Knightswood. Again, it was external influences that were preventing the building of the houses 'for heroes'. The Great Depression, not relieved until the Second World War, stopped most social housing being built.

Of course, this was exactly the time houses were needed. Those 'slum' areas that were left, including most of the Gorbals and parts of Anderston, Springburn, Bridgeton, Townhead, Cowcaddens and Kinning Park, had to be dealt with. But with the lack of funds to build, deprivation and the dole brought misery; violence erupted in the streets and again was not relieved until stopped by Percy Sillitoe's police and the Second World War.

It is this interwar period that created the myth of Glasgow slums. However, in the totality of what was, and is, Glasgow, the Gorbals and these other areas could

not be said to sum up the city. When you take into account the ever-expanding city areas including Kelvingrove, Hillhead and Queen's Park, there were plenty of fine and adequate buildings. When you then include the expanded burghs, taking into account Anniesland, Cathcart, Langside and so on, you would find that in fact, there were very few areas that could be called slums. Even the 85,000 people in the Gorbals and Hutchesontown areas could not be called to account for being slum dwellers. They were living in desperate conditions, but often making the best of it while the city prepared for rebuilding. Knightswood gives an idea of the very real attempts that were made to correct this.

3c. Lewis's Royal Polytechnic (1932), No. 97 Argyle Street, G2 8AR

If any Scottish building is representative of the golden age of the department store then it must be the Lewis' building in Glasgow's Argyle Street. I remember well the early wooden escalators and the bank of elevators managed by a uniformed attendant who would take us from the basement (where my dad could buy singles

Debenhams.
Inset: Lewis' advert.

for the Dansette) to an upper floor full of toys and trains, which was a schoolboy's dream and where, at Christmas, hosted Santa in his grotto. It was probably unique in Scotland that Santa would make his way by carnival procession down Argyle Street to Lewis' and watched by thousands.

Lewis' was one of a chain of department stores founded in Liverpool; it was in business from 1856 to 1991 when it went into administration. The Argyle Street store became Debenhams above with a variety of shops on the ground floor.

On this site originally was John Anderson's Royal Polytechnic department store, known as 'The Poly'. The company was taken over by Lewis', who already had a store in Liverpool. The design commissioned was that of Scottish architect James Hoey Craigie, whose work is reputed to include the small, but iconic, Corona Bar at the corner of Pollokshaws Road and Langside Avenue. Gerald de Courcy Fraser also seemed to have a hand in the design. He was an architect for Lewis' and possibly took over after the death of Craigie in 1930.

There are few buildings in Glasgow built from Portland limestone from Dorset, which, while strikingly white, would have been rather expensive compared to local red sandstone.

31. Finnieston Crane (1932), Finnieston, G3 8YW

I would be remiss if I was to ignore this massive engineering marvel that sits in homage to Glasgow's industrial past. Formally known as the Stobcross Crane, it was used not only to install the machinery of great ships, but was also in constant use loading the products of our factories (particularly of the North British Locomotive works in Springburn). It is estimated that as many as 30,000 locomotives were hauled through Glasgow's streets by steam traction engines to be loaded on board vessels sailing to the far corners of the globe.

For some reason the contract was split between three bridge builders. The tower was the work of Cowans Sheldon & Co. of Carlisle and the gantry by the Cleveland Bridge & Engineering Co. of Darlington. The crane was commissioned by the Clyde Navigation Trust under their mechanical engineer Daniel Fife. Strangely enough, the contract did not go to the most likely builder, Sir William Arrol, who had built the Titan Crane at the Clydebank yard of John Brown & Co. They were however, involved in the construction of the substantial foundations.

Cowans Sheldon is no longer in business, while Cleveland Bridge is still busy and has had a hand in the new Queensferry Crossing.

Sir William Arrol and Co. will forever be remembered as the builder of Tower Bridge in London, North Bridge in Edinburgh, as well as the new Tay Bridge (completed in 1887). William Arrol was one of the greatest Scottish engineers and industrialists. From Houston, in Renfrewshire, he was the son of a cotton spinner and also started work in Coat's mills, aged ten. A few years later he trained as a blacksmith with Reid's of Paisley. Like many young Scottish entrepreneurs of the

The Finnieston Crane.

time he undertook night classes, where he learnt engineering. At aged twenty-four he became a foreman in the Glasgow boilermaking company, Laidlaw and Sons, where he was well respected for his engineering skills.

By the time he was twenty-nine he started his own engineering business in Dalmarnock, which went on to become an international success and continued in business until 1969 when it was taken over by Clarke Chapman. The Dalmarnock Iron Works were closed in 1986.

32. Telephone Exchange, Centre Street (1935), No. 243 Centre Street, G5 8ED

In homage to the high number of derelict, but interesting, buildings in Tradeston and Kinning Park, this pretentious telephone exchange stands among other redundant industrial buildings located just along the road from Scotland Street School. I have asked people to guess its purpose as it is very hard to fathom.

This three-storey, rectangular, baroque revival building of red brick and sandstone ashlar was built by Glasgow's Office of Public Works. It stands as a monument to Glasgow's history in telecommunications. I don't think this is part of the national network as Glasgow's private exchange had been sold to the General Post Office in 1906 and there was already an exchange in Glasgow. This was possibly a Glasgow Corporation internal exchange.

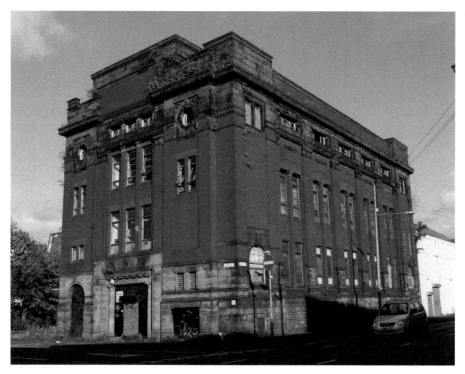

Telephone Exchange, Centre Street.

Telephone House, Pitt Street, 1937.

33. The Daily Express Building (1936), No. 145 Albion Street, G1 1QS

I was always fascinated by this building, not just for its looks, but for the fact that in this area I could wander around where the newspapers of the day were printed and published. In Hope Street you could look through the huge windows and see the presses rolling. Here in Albion Street was the Daily Express, where the area would be jammed at times by the little delivery vans taking the papers to the newsagents or to the railway stations.

The Daily Express building was of course different, but being Glasgow, that was fine. New styles and invention was always welcome, as long as it worked and it was pleasing to the eye. The building was the work of Ellis & Clark and Sir Owen Williams, who had already been responsible for the sister buildings in London and Manchester. It has a reinforced concrete frame but its façade is clad in glass and black Vitrolite.

Vitrolite (an opaque pigmented glass) was manufactured in Great Britain by Pilkington Brothers. Produced in various colours it began to be used from the 1920s to the '50s and was often used in art deco and art moderne buildings. It was also used in kitchens and bathrooms. However, it is brittle and became both difficult and expensive to replace. It was also often used on shops, and particularly

The Daily Express building.
Inset: Black Vitrolite reflects Strathclyde University's new Technology and Innovation Centre.

café fronts. You can still see it on Rogano's restaurant in Exchange Place and on various cafés throughout the city.

The building originally had four-storeys but new floors were added in 1988, the same year that the building was taken over by the Glasgow Herald and Evening Times. The Herald later moved to new premises and the building has now become a block of flats.

34. Luma Light Bulb Factory, Linthouse (1938), No. 510 Shieldhall Road, G51 4HE

The Luma Building is one of Glasgow's iconic modernist structures and has a special place in Scottish industrial history. It was built in a rare partnership between the British Luma Co-operative Lamp Co. and their counterparts in Sweden, Kooperativa Förbundets. The factory was a response to the Phoebus cartel in the manufacture of light bulbs and the resulting high prices.

The cartel included Osram, General Electric and Phillips and from 1924 to 1939 engaged in protecting the price of bulbs as well as engaging in planned obsolescence. It also prevented technological advances that would have produced longer lasting bulbs and brought down the price. The cartel even fined member companies that produced lamps that lasted longer than 1,000 hours.

Phoebus tried to stop this independent development but was unsuccessful. In any case, the Second World War effectively brought the cartel to an end and the Luma companies in Scandinavia and in Glasgow went on producing bulbs until the 1960s.

It is a rare example in Glasgow of an art deco building and was built to coincide with the Empire Exhibition that same year and held in the nearby Bellahouston Park.

Its designer, Cornelious Armour, was a house architect for the SCWS who worked on a number of their factories and shops. Not a lot is known about his original work although he is credited with extensions to the SCWS linoleum factory (a listed building still in Falkland, Fife). Interestingly, the same Swedish cooperative also had an interest in this factory. The fact is that Cornelius may simply have been a project architect working to a given design because the Luma building is strikingly similar to the Luma building in Stockholm, designed by Artur von Schmalensee and Eskil Sundahl in 1930. Like Luma in Glasgow, the Lumafabrikens buildings in Stockholm (now called Luma Park) are listed and preserved as offices and housing.

It is a steel framed building with precast concrete slabs on the upper floors and a concrete base. The steel frame was protected by concrete; the steel windows were by Critall, by now familiar in many new buildings.

The tower has a very practical use: to test light bulbs for longevity. Light bulb production went the same way as much of the light engineering and manufacturing in the area: the factory was used for other purposes, including a caravan showroom 'Caravan Land'. In 1993 when demolition was on the horizon, the building was taken over by Linthouse Housing

Above: Luma Building.
Right: Luma Tower.

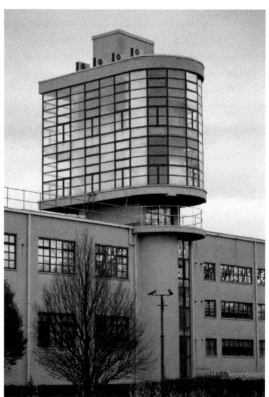

Association who converted it into affordable housing. Additional apartments of the same design were built behind.

The Luma Tower has won a number of awards, including RIBA in 1997 and the Europa Nostra Award in 1998. The tower continues to welcome travellers to Glasgow, particularly those arriving by air since it is now illuminated at night in neon blue; in fact some people have in the past confused it with an airfield control tower. It continues to serve as a beacon to Glasgow's industrial past as well as international cooperation.

When you visit the building you can also take in the new Queen Elizabeth University Hospital, which you can't miss as it is right behind it.

35. The Tait Tower, Empire Exhibition (1938), No. 16 Drumbreck Road, G41 5BW

In 1938 the country was down in the dumps. The thirties had been a horrible decade: industrial decline, stagnation and idleness were the abiding atmosphere. Something had to be done to enliven the spirits, strengthen resolve and improve the economy.

What the new Scottish National Development Council came up with was a new exhibition: The Glasgow Empire Exhibition. Successful trade and industrial exhibitions had been held in Glasgow in 1888, 1901 and 1911 and what emerged was that Glasgow loves an exhibition.

The idea was enormously successful, attracting twelve million visitors to the site at Bellahouston Park. The Park became a modernist town of pavilions laid out on wide avenues. There was Scottish Avenue, Colonial Avenue and Dominion Avenue. All the great national and Scottish firms were represented. There was ICI,

South Cascade and Tait Tower.

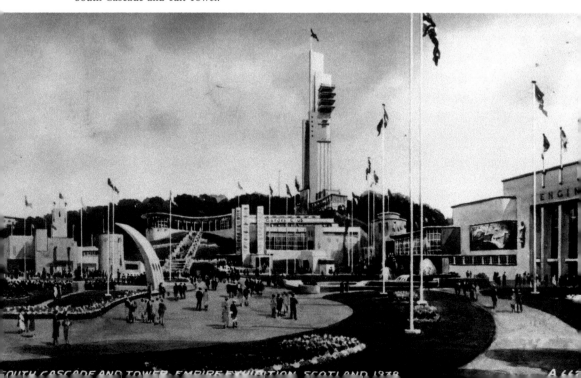

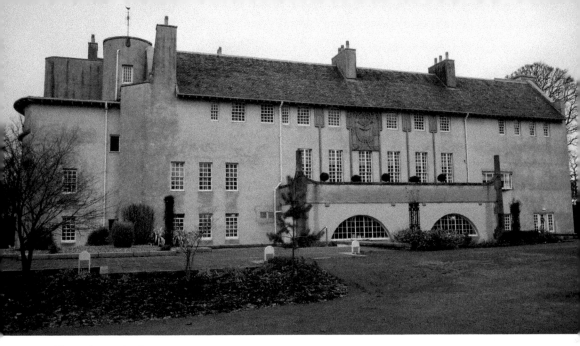

House for an Art Lover.

Beardmores, Templeton, Colvilles, Shell and Dunlop. Churches had also been built these included the Church of Scotland and the Catholic Church.

The exhibition was soon to be overshadowed by the coming Second World War, but it lives on in the folk memories of Glaswegians. My own parents had been there and spoke fondly of it. Its purpose was to promote trade and strengthen links with the Empire. If its aim was to bring a bit of optimism into people's lives, then it certainly did that.

The exhibition was a celebration of modernist architecture and featured the work of young and modern architects. These were Glasgow's Jack Coia, Basil Spence, A. Esme Gordon, Launcelot Ross, Gordon Tait, Thomas Marwick, A. D. Bryce, Margaret Brodie and James Taylor Thomson. During the thirties, there had been precious little building in Glasgow. There was no money. The exhibition was the opportunity to show what could be achieved and it probably promoted the careers of some of the architects.

Centrepiece in all of this was the Tait Tower. The officially named, 300 feet high, 'Tower of Empire' sat above the exhibition. Like the other pavilions, it was white – dazzling, with clean futuristic lines, the likes of which may have been seen in contemporary comic books. It was the tallest structure in Great Britain at that time; Glasgow could be seen spread out below from its observation decks, with Campsie Fells in the distance. Below the tower was the Atlantic restaurant, styled like the prow and bridge of an ocean liner.

In charge of the architectural team and responsible for the tower was Thomas Tait. He was a Paisley 'buddy' who studied at Glasgow School of Art under Eugene Bourdon, a proponent of Beaux Arts. He joined the London practice of Sir John James Burnet where he was responsible for the design of the columns for the Sydney Harbour Bridge, as well as the modernist St Andrew's House government building in Edinburgh.

The exhibition and the choice of architects was another example of Glasgow taking a risk with architecture. The exhibition became the largest collection of art moderne in Great Britain – all designed by young architects. The streamline moderne style is one that features nautical lines, balconies, portholes and straight lines. This probably struck a chord with the Glaswegian at Bellahouston Park, which is hardly any distance from the Clyde where the great RMS Queen Mary had been completed only a couple of years before. In the middle of the exhibition, in August 1938, it won the Blue Riband for the fastest Atlantic crossing westward – what elation there must have been that day at the exhibition and in Glasgow.

There is very little remaining of the exhibition. While the intention was to keep the tower, it was demolished in 1939 as it may have been a target for bombing. The Palace of Engineering was bought by Scottish Aviation and moved in 1941 to Prestwick airport, where it still used by Spirit Aerosystems to assemble aircraft parts.

However, while there is little left of the exhibition you can visit the House for an Art Lover which opened in the park in 1996 and is an art gallery, studios and visitor centre. It is based on Mackintosh's unrealised designs for a country retreat submitted to a German design competition in 1901. Both 'Mac' and his wife Margaret Macdonald worked on the designs.

36. Beresford Hotel (1938), No. 460 Sauchiehall Street, G2 3JW

If people were going to visit the Empire Exhibition, then they would need somewhere to stay, and William Beresford Inglis' enterprising plan was to give them a hotel that would be commensurate with their expectations of the exhibition. This was the Beresford Hotel, one of the few still existing art deco or 'streamline moderne' buildings of the period, and certainly one of the largest in Great Britain. Weddel and Inglis were the architects, Inglis also being the entrepreneur behind the building.

The building features the round towers common to art deco and is strikingly similar to the façade of McNair & Elder's Ascot Cinema in Anniesland, which now fronts a block of flats. You might think that the architects also had a look at Mackintosh's Scotland Street School as the twin-glazed towers are similar in concept.

The hotel was popular during the exhibition, but as war enveloped Glasgow it was requisitioned and became a home to military personnel, particularly American servicemen. Later generations of American sailors from the Holy Loch also visited the Beresford Bar, which was on the ground floor. It must have been in their folk memories.

Another American connection is that the young John F. Kennedy, later to be President Kennedy, visited the Beresford Hotel in September 1939. He was on leave from Harvard University and was asked by his father, Joseph Kennedy, the Ambassador to Great Britain, to visit American survivors who had been taken to the hotel to recover from the sinking of the liner Athenia.

The ship was the first to be sunk by a torpedo in the Second World War; it was around 200 miles into the Atlantic, outward bound for Montreal. The 128 passengers and crew onboard were killed. Among these were many Jewish refugees, Canadians and American citizens.

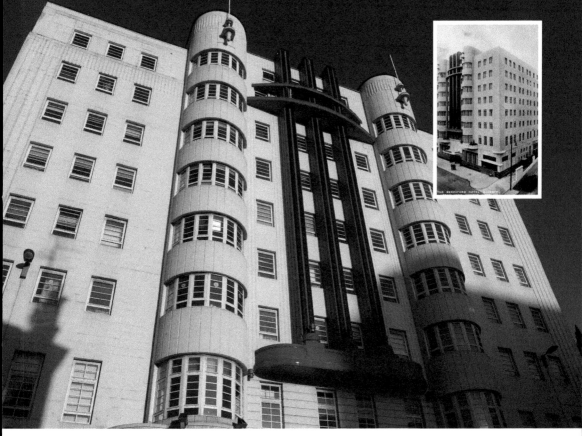

The Beresford Building.
Inset: The Beresford Hotel, 1938.

After the war and a short return as a hotel, the building was sold to Imperial Chemical Industries as offices and became known as the ICI Building. In 1964 it was taken over by Strathclyde University and converted to a hall of residence, being renamed Baird Hall in memory of John Logie Baird, the inventor of television. It was sold in 2003 and has since been converted into private flats.

37. The Cosmo/Glasgow Film Theatre (1939), No. 12 Rose Street, G3 6RB

The Glasgow Film Theatre is on the list because as The Cosmo it was Scotland's first art-house cinema. It was opened in 1939 and was represented by Mr Cosmo, a dapper little cartoon chap wearing a bowler hat. Mr Cosmo was said to represent George Singleton from a family of Glasgow cinema owners who had opened the art house. When Mr Cosmo closed his doors in 1973, it was to reopen a year later as the Glasgow Film Theatre.

It is a rare building of exposed bricks, certainly on this scale anyway. Brick had been used substantially for factories and smaller buildings, such as tenement washhouses. It became more common as air-raid shelters went up throughout the city, but with larger domestic or commercial buildings it had normally been covered up with harling or cement.

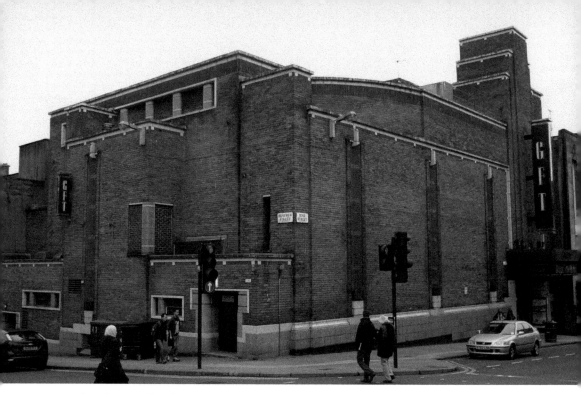

The Glasgow Film Theatre.

The building was the work of architect W. J. Anderson II, a partner in John McKissick & Son (specialists in cinema design). The Cosmo is said to have been inspired by the buildings of Dutch architect Willem Marinus Dudock, who was the Hilversum city architect responsible for a range of modernist buildings in brick. The bricks here are brown, with cream detailing. The building is set on black Swedish granite.

38. Moss Heights Cardonald (1952), Moss Heights Avenue, G52 2TZ

The Moss Heights were a foretaste of what was to come. They were Glasgow's first high-rise development and standing ten storeys high they must have seemed colossal to those citizens used to the 'room and kitchen'. Designed with all the 'mod cons', it might have been churlish to point out that the lifts were too small to take coffins and the huge wooden furniture of the time.

The site had originally been chosen for three-storey tenements housing 180 families. An alternative plan saw Ronald Bradbury design multi-story flats instead, these being carried forward by Archibald George Jury. Ronald Bradbury was Glasgow's Director of Housing, before he moved in 1948 to Liverpool as City Architect.

It was Archibald Jury's tenure in Glasgow as City Architect from 1949 to 1972 that saw the vast building programme that extended the city beyond its known limits and created the housing schemes of Easterhouse, Drumchapel, and Castlemilk among many others.

Moss Heights in 2015.
Inset: Moss Heights.

The whole complex, built between 1950 and 1954, used reinforced concrete frames. There were 263 houses in total, 219 four-apartment flats in three ten-storey blocks, and forty-eight three- and four-apartments in two four-storey blocks. They were billed as 'modern luxury flats' with all the modern amenities, which included a kitchenette and bathroom.

39. Our Lady and St Francis Secondary School's annexe, Charlotte Street (1964), No. 72 Charlotte Street, G1 5DW

In 1846, among the first Catholic religious communities to be welcomed back to Scotland after the Reformation were the Franciscan Sisters. In 1846 they opened a convent at Glasgow Green. This was supplemented by a girls' school, which was expanded in 1923. This new modernist extension was opened in 1964. It was one of many commissions by the Glasgow architects Gillespie, Kidd and Coia for the Catholic Church.

With falling school rolls in that part of Glasgow and a general move away from co-educational senior schools, it was decided that the school could not be sustained and it closed in 1989 despite protests and merged with St Mungo's Academy, moving to Crownpoint Road in the East End.

The first two levels of the four-storey structure feature a brick and glass infill in a concrete frame. Above, the top storeys appear to float; their angled façades

allowing light into the classrooms below. The expanse of glazing is a counter to the concrete that has been poured into rough shuttering, leaving the grain exposed: a technique that would be used more and more. The glazed stairwell breaks up the solidity of the hard frontage and the roof structure; the arched window at the base lends additional interest.

There are a number of basic principles that apply to modernist architecture, and this building uses them. First of all is its simplicity and its straight horizontal and vertical lines, the exposure of the bricks and the concrete in which the outline of the shuttering can be seen. The choice of blue-black brick lends some unexpected colour and contrast to the concrete. Concrete was used increasingly as we moved into the 1960s and 1970s and this would have been an excellent lesson in the sensitive joining of new and traditional materials and methods. It sadly wasn't normally the case in Glasgow.

The extension is the only remaining part of the building. It deserves to have survived and been given an A-listing. It is now the headquarters of a social enterprise, the Wise Group. Its position opposite the parklands of the vast Glasgow Green give it a wonderful view. It takes a well deserved place in the continuing redevelopment of this once desolate area and the building, which does need a little refreshing, has a bright future.

Our Lady and St Francis Secondary School's annexe.

4c. Livingstone Tower, Strathclyde University (1964), 26 Richmond
Street, G1 1XH

I had always thought that the Livingstone Tower had been purpose-built
for Strathclyde University and it was only in the research for this book that
I discovered my mistake. In fact the tower was built as a commercial enterprise
between Glasgow Corporation, the Royal College of Science and Technology and a
development company. The site had originally been a row of tenements to be cleared
as part of the Townhead Comprehensive Development Area.

In the event, the enterprise was not attractive to business tenants and was adopted
by the expanding university. Originally called Alec House, the building was renamed
after David Livingstone, who had been a student at Anderson's Medical School, a
precursor to the university.

I have put this in the collection as it stands out from the grey, soulless, brutalist
buildings that were being erected at the time. Despite being comprised of reinforced
concrete, it has some colourful character to it: the curtain wall is of dark green glass,
framed with orange metal.

The tower sits on a concrete platform and is joined by walkway to the McCance
Building. Underneath there is a row of shops. The planned restaurant did not
materialise and it is only recently, with the development of the Merchant City that
any of these units have shown any longevity of use.

Livingstone Tower, Strathclyde University.

At the time of its building, the tower was one of the earliest high-rise commercial buildings and is still a prominent landmark in the East End. The architects were Covell, Matthews & Partners and it was built by Sir Robert McAlpine.

41. Anniesland Court (1968), Nos 833–835 Crow Road, G13 1LE

J. Holmes & Partners' Anniesland Court is compared to Ernö Goldfinger's Trellick and Balfron Towers in London and features the same separation of stairs and lift columns. This style of building has been dubbed 'Scottish brutalist' but I think it is deserves much better than that.

Holmes and Partner's tower block is plonked right in the heart of Anniesland Cross; at one time, the largest road interchange in Great Britain without underpasses. It is the only high-rise block of flats in Glasgow to have an A-listing. But it is an isolated building. The area has many unrecorded coalmines, making building in the area rather difficult. As the city moved westward, Anniesland, Knightswood and Jordanhill emerged as areas of low-rise rather posh apartment buildings and higher quality red sandstone council and private building.

The tower came as a bit of a surprise to local residents, myself included, to see this huge building rise. Before its opening I was struck by the 'Lego' effect of the successive banding of dark and light levels, which gave a tiled symmetry to the building. This symmetry was immediately destroyed as soon as the tenants put up their many coloured curtains. I wonder if the architects had thought of this.

The idea of the 'maisonette' became popular in Glasgow in the 1960s: flats with two levels were built within apartment blocks. It was the same here in the twenty-four storeys that contain seven levels of homes. I used to laugh at the idea of Jeanette in a maisonette with a kitchenette and a dinette.

The patio area on the first floor had been designed with shops in mind, but they were unable to be let because of the anti-social behaviour around the unsupervised ground areas. This was remedied to a great extent by the improvement in security and use of concierges in all high-rise flats in Glasgow.

Council and other offices occupy the ground floor of the block, while a patio level above has a branch library. The block is housing stock transferred in 2003 to the Glasgow Housing Association and is managed by the Great Western Tenant Partnership.

The tower is probably one of the most successful of the high-rise buildings in Glasgow, many of which have now disappeared. In 1947 a contingent of Glasgow councillors and planners visited Marseilles in the south of France to look at the work of the modernist architect Le Corbusier. His ideas were adopted with enthusiasm and Glasgow looked to its builders to emulate his principles of *unité d'habitation*.

Le Corbusier's buildings on concrete piers were seen as vertical towns for living in and his Cité Radieuse in Marseille incorporates shops, restaurants and sporting and leisure facilities. Unfortunately, while the ideas may have been workable in the warm south of France and in its culture, there was absolutely no clear thinking as to whether these ideas would work in Scotland.

Anniesland Court.

In fact, they generally did not. The tower blocks that were thrown up with undue haste were to come down after relatively short lifespans. Perhaps one of the biggest failures was with Basil Spence's Queen Elizabeth Square development in Hutchesontown in the Gorbals ('Hutchie C'), also christened the 'Hanging Gardens' because of the prominent (and mostly unused) balconies at the ends of the buildings.

It wasn't long before the high cost of maintenance began to take its toll. The buildings suffered from damp, which was often blamed on residents not opening windows and not on the flawed design of the buildings. The poor conditions, as well as vandalism and anti-social behaviour, led to numerous complaints and protests, including the withholding of rent. Eventually the game was up. Despite a renovation programme in the 1980s the problems persisted and the buildings were pulled down to the enormous relief of many.

The same was true of many of the buildings of the period. Broken lifts, choked rubbish chutes, overflowing bins, vandalism, neglect and, more dangerously, objects been thrown from the buildings, all conspired against the flats.

Anniesland Court also suffered some of the same issues of vandalism and anti-social behaviour, but has survived as a reminder of what might have been if Le Corbusier's principles had been followed with some local flexibility and the taking into account of the locality and needs of the people. After all, it is not unattractive and has become an icon in the west end.

42. BOAC Offices Buchanan Street (1970), No. 85 Buchanan Street, G1 2JA

Buchanan Street is a walk through the architecture of the ages. At the top of Glasgow's finest street are Glasgow's Royal Concert Hall and Buchanan Galleries, the former a replacement for the fire destroyed St Andrew's Halls and home to Celtic Connections and the Royal Scottish National Orchestra.

As you move down you will pass Burnett and Campbell's elegant Old Athenaeum, original home of the Royal Scottish Academy of Music and Drama (RSAMD). You will delight in the mixed styles, including art nouveau and Scots baronial. There is Glasgow's A-listed gothic Stock Exchange and Miss Cranston's Tea Rooms by George Washington Browne. At the bottom are the department stores vying with one another for attractiveness and variety of architectural style.

In the midst of all this are the former British Overseas Airways Corporation (BOAC) offices which were the work of Andy MacMillan and Isi Metzstein of the Gillespie, Kidd & Coia architectural practice. It is about their only secular work in Glasgow. This modernist B-listed building is a framed structure clad

Opposite: The former BOAC offices.
Opposite inset: Buchanan Street. The bland building to the left at the side of the lane (with the garden hut on top) is the site of the BOAC building.

PRETTY GREEN

MACKINTOSH

with copper on the top of three storeys. I love the way the light reflects from the cleaner windows. The building does need a bit of TLC to show it as it was intended.

Gillespie, Kidd & Coia are a legend in Scottish architecture, mostly as a result of their work for the Catholic Church. Their use of modernist principles and the wide latitude given by the client has produced some stunning buildings, including the internationally recognised, but disused and abandoned, St Peter's Seminary in Cardross. I am relieved that work is underway to preserve what is left of it.

I was taken by surprise on a visit to the University of Cambridge where I was attending a conference in Robinson College. This beautiful red brick building houses learning facilities, as well as student accommodation and a delightful chapel featuring stunning stained glass. It is centred on a large tranquil garden and lake. The college was also the work of Andy MacMillan and Isi Metzstein. Robinson College is considered to be a masterpiece and in 2008 was recognised as one of Great Britain's five most inspiring buildings by the *Daily Telegraph*. If you can't get there, and even if you are not a Catholic, you must visit some of the company's work, particularly St Paul's in Glenrothes, which is probably Britain's first modernist church.

43. Burrell Collection (1983), Pollok Country Park, No. 2060 Pollokshaws Road, G43 1AT

Glasgow is a city that has enabled those with vision to excel, particularly in trade with the world. Those entrepreneurs went beyond serving our own shores to join us with the Americas and the British Empire. This great merchant enterprise was to last up to the Second World War, when disruption, competition, and cost were to bring the beginning of the end for the operation of liners, followed by cargo steamers.

It was the Scottish entrepreneurs like Paddy Henderson and George and John Burns who grew this great merchant fleet. Another of these and perhaps the greatest name in Scottish shipping, as well as in Scottish art and culture, was Sir William Burrell, born in 1861 into a shipping family. William and his brother took over the running of the firm from their father. They were astute in ordering modern ships at low cost when the market was in a slump and then selling these on at profit when the market picked up. This made them very rich and this allowed William Burrell to indulge his passion for collecting art and antiques.

The company had started in William's grandfather George's time, plying trade along the Forth and Clyde canal. With the purchase of a share in a steamship in 1866, their business expanded worldwide, acquiring six more steamers by 1875. After years of successful trading, the brothers again used the rise in the market value of ships, caused by the outbreak of the First World War, to sell. Between

Burrell Collection.
Inset: Burrell Collection interior.

1913 and 1916 almost the entire fleet was sold, including vessels that were still on the stocks. William Burrell invested the proceeds and embarked on his passion for collecting works of art.

In 1944 Burrell gave away almost all of his art collection to the city of Glasgow, along with a bequest of £250,000 to house it. Burrell was knighted in 1927 for services to art and the city. He died in 1958 and is buried in Largs.

It was Tom Honeyman, Director of the Kelvingove Art Gallery and Museum, who was instrumental in attracting the bequest of Sir William to the city. However, there were very strict conditions concerning where his great collection was to be shown. It had to be housed in a building sixteen miles outside the city to prevent the artwork being affected by Glasgow's smoke and fog. Besides 500 paintings and 600 stained glass panels, the collection includes priceless Gothic tapestries, which would undoubtedly have been destroyed if they had been hung in the wrong conditions anywhere near Glasgow in 1944.

However, over time, with the introduction of the 1956 Clean Air Act, it was possible for the trustees to amend the conditions when Pollock Country Park was gifted to the city of Glasgow by Mrs Anne Maxwell Macdonald in 1966. The Pollock Estate and House had been established by Sir William Stirling-Maxwell, Scottish historian, writer and politician. Anne was his granddaughter, but her father John Stirling-Maxwell had also been committed to preserving the huge green space in the estate and giving Glaswegians access to it. This was eventually achieved, providing Glasgow with one of Europe's largest green city spaces as well

as a country house, now run by the National Trust, as well as the land on which to build a home fit for the Burrell Collection.

Holding a design competition is common for important public buildings and this has given Glasgow many interesting constructions. Such a competition was held in 1971, with a submission by Barry Gasson, Brit Andresen and John Meunier winning.

The 'L' shaped sandstone, glass and steel building is set in a substantial grassy area, allowing the structure to be viewed from a distance but blend with the landscape rather than fight against it. Romanesque doorways and other items are incorporated into the building, with a sixteenth-century stone archway as the main entrance. The rear glazed elevations look into a wooded area but provide the light that allows full appreciation of the treasures in the uncluttered galleries.

Also incorporated and installed in an internal courtyard of mellow red sandstone are reconstructed rooms from Burrell's Hutton Castle. These show how he used the beautiful medieval, and later, artefacts on a daily basis. It was a specific requirement of Burrell that these rooms be recreated; I am sure he would be happy with how they have turned out.

The building is now A-listed and considered second only to St Peter's Seminary in Cardross as Scotland's greatest post-war architectural design. It is a lovely building that blends perfectly with its environment and its intention. It would be a wonderful place to wander round in quiet solitude, but that would be rare because it has been accepted by the Glasgow citizen and while it is not noisy, it is certainly busy. There are plans to expand the gallery and make basement storage areas into additional galleries. This will be a sensitive operation, but if the refurbishment of the Kelvingrove Art Gallery and Museum is anything to go by, the reopened Burrell Collection gallery will be worth the three year wait during its closure.

If you visit the Burrell then do also visit Pollok House. Sir William Stirling-Maxwell was a collector of Spanish art and in 1948 produced the seminal book on the subject *Annals of the Artists of Spain*. Some of his art collection can be seen in Pollok House; a highlight is El Greco's *Lady in a Fur Wrap*.

44. Clyde Auditorium, 'The Armadillo' (1997), Exhibition Way, Finnieston, G3 8YW

It might have come as a surprise to all that the Scottish Exhibition and Conference Centre (SECC) became so popular, but then again, we Scots love exhibitions. So, by 1997 there was again a capacity problem, solved with the Clyde Auditorium or 'The Armadillo' as Glaswegians have dubbed it.

The Armadillo was a product of the famous Foster & Partners. It might look like the Sydney Opera House, but its origins are from the idea of upturned and interlocking ship's hulls to recognise the history of this great shipbuilding and merchant shipping area.

The Armadillo.

Foster and Partners are possibly the most famous architectural practice in Great Britain. It is still led by its founder Norman Foster. The partnership has been responsible for numerous major and prestigious projects. The most familiar may be 30 St Mary Axe in London, otherwise known as 'The Gherkin'.

45. Homes for the Future (1999–2000), Greendyke Street, G1 5PX

Many Glaswegians know that their architectural heritage is special. Many of us love our buildings; the rich red sandstone decorated tenements, the highly decorated granite civic buildings and offices. They love their Victorian galleries and their great and quirky parks with the Fossil Grove or the old Flint Mill on the Kelvin.

We also know that many people outwith Glasgow have had no idea of the richness of Glasgow's history and what it has to offer the visitor. The Burrell Collection could only go so far in enlightening them. It took a long time for Glaswegians to say 'Wait a minute. We have something special here!' The Glasgow Garden festival did a lot for that and just as much did winning the European City of Culture in 1990 and surprising, to the Glaswegian especially, was the award as the UK City of Architecture and Design, in 1999.

The year-long retention of the award brought economic benefits to the city of around £34 million, as well as the lasting legacy of Scotland's Centre for Architecture and Design and the City in The Lighthouse, the Mackintosh building which once housed *The Glasgow Herald*. At the head of this year was Deyan Sudjic OBE, a highly respected writer and broadcaster and co-founder of 'Blueprint', the

Homes for the Future.

influential monthly architectural magazine. He is now currently the director of the Design Museum.

One other lasting benefit to the city was 'Homes for the Future' a three-phase programme that would eventually create 250 modern homes and would preface the larger renewal of the industrial East End.

Years after the completion of the first phase of the work, it is easy to see what kind of risk had been taken on this site that overlooks Glasgow Green, alongside a derelict leather and tallow works and the former Catholic Girls School annexe, Our Lady and St Francis. While it is a Gillespie, Kidd and Coia product and an A-listed building, it still needs a bit of TLC.

While there are still some vacant and derelict sites around it, Homes for the Future, overlooking the wide expanse of the restored and landscaped Glasgow Green, could be overlooking a park in the West End. There is a fair bit to go, but these buildings have helped to establish the area as one worth considering as a place for living and they are not too far from the Merchant City. And at this point, it looks as if the risk was worth it, as these properties have increased considerably in value and have started to make the case that the West End is not necessarily the best end.

 Working to a master plan created by Page & Park Architects and Arup Associates, the first phase, through a competition, brought together seven international architects to design 100 showcase apartments that would include private and social housing.

 RMJM provided a four-storey block with a block of linked maisonettes. There are apartment blocks by Elder and Cannon, Ian Ritchie and Rick Mather. The stepped terrace block is by Ushida and Findlay. McKeown Alexander and Wren Rutherford also contributed buildings. It is a line of apartments whose coherent paintwork and long walkway brings it together as a whole and provides a pleasant border to Glasgow Green.

46. Glasgow Science Centre (2001), No. 50 Pacific Quay, G51 1EA

Glasgow's Science Centre is now one of Scotland's major tourist attractions, but it is just as important as a learning centre and from where it stands you can breathe in some of Glasgow's industrial and commercial history.

The Glasgow Science Centre.

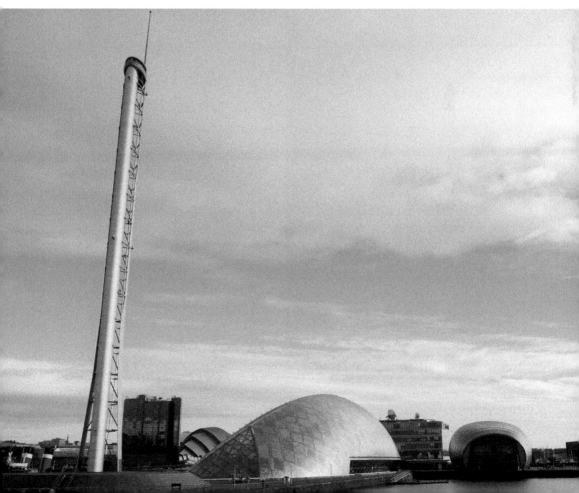

Opened in 2001, it is now a key part of the Clyde waterfront regeneration area and stands where the wonderful 1988 Garden Festival was held after the docks were cleared of the remains of the once massive iron ore cranes and other aspects of the Prince's Dock.

There are three buildings in the complex, all clad in bright titanium. On this spot there was a 'canting basin' where ships were once brought to have their hulls scraped of barnacles. The upturned boat shape represents this and holds three floors jam-packed with science learning and features many interactive displays, including a planetarium.

The largest of the three main buildings has a crescent shaped structure and houses the Science Mall. The exhibits encourage interaction and they can be used or played with as part of the informal learning experience the centre aims to deliver.

The architecture of the Science Centre was by the Building Design Partnership (BDP), a major player in British and international architecture. They have been responsible for a number of Scottish buildings; if you go to Aberdeen, their Sir Ian Wood building at the Robert Gordon University is well worth a visit.

You can't miss the Glasgow Tower, but sadly you may not see it turning as it should. It was designed as the world's tallest freely rotating tower, but it got stuck at an early date. Attempts were made to restart it but it has only had sporadic bursts of movement. What is true is that, according to the *Guinness Book of Records*, it is the world's tallest free-standing tower capable of turning 360 degrees.

47. Riverside Museum (2011), No. 100 Pointhouse Place, G3 8RS

Glasgow's transport collection is important to the city, as is Kelvingrove Art Gallery and the Burrell Collection, but we needed somewhere fitting to display the vast collection after many years in short-term accommodation.

I first saw the city's model ship collection when I was younger, when it was crammed into the halls of the Kelvingrove Art Gallery. These were working models built to display the full size version as it was being built. They were donated to the city by the shipbuilding companies that built the originals.

These models, along with the trams, cars, bicycles, locomotives and lorries all built or used in Glasgow, were moved in 1964 to the old Coplawhill Tram Depot (now the Tramway arts centre) and then to a section of the Kelvin Hall, opposite Kelvingrove Art Gallery.

The status of one of the greatest of Great Britain's transport collections demanded a building that would suit the purpose and that would adequately welcome the growing numbers of appreciative visitors.

The city has done it with style because, with our ongoing relationship with experimentation, what was chosen was as dramatic as it was surprising. It is in a most appropriate location on the riverbank, where, at A. & J. Inglis shipyard, 500 ships were built over a period of 100 years. The tender for the design of the museum was won by Zaha Hadid Architects and engineers BuroHappold, who were in competition with the likes of Norman foster and Richard Rogers.

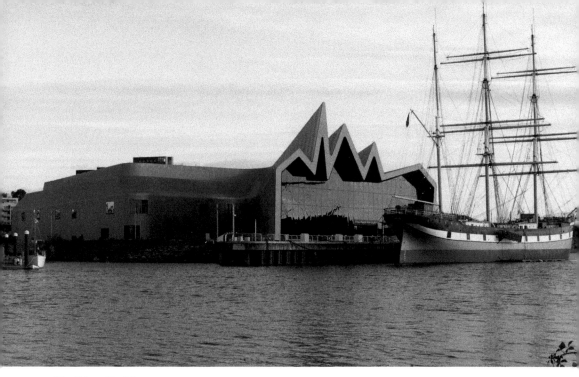
The Riverside Museum.

The building is spectacular and as I watched it being built, it was with growing excitement as to what would be the final product. And the building doesn't disappoint. Its mountainous façade is reminiscent of Glasgow's history of church and industry. Its huge glass frontage allows ample light to penetrate this mammoth building and also reflects The Tall Ship (the Glenlee) anchored in front of the building.

I also have to be careful of any criticisms as they may be based on my previous experiences of the collection. Visitors do seem to agree that the motor cars, which are placed on shelves that rise to great heights, don't allow the enthusiast to see inside them and mostly appear as far-off exhibits. However, the way in which the ships are displayed is delightful: while some of the larger ones are fixed in place, many of them are on an endless conveyor, letting them slowly sail into sight.

I would also have liked to have seen some of the tools and people who designed and manufactured these exhibits, as the Clyde story is as much about that as about the product. The Summerlee Heritage Park in Coatbridge is a great place for this but I think that Glasgow deserves one too.

Dame Zaha Mohammad Hadid is the first woman to be awarded the Royal Institute of British Architecture's Gold Medal award in 2015. Her buildings are described as 'neofuturistic' and it is clear that Glasgow is taking another gamble here. Hadid has been accused of putting experimentation first and producing buildings that first of all are difficult to build and which, thereafter, can be difficult to maintain and heat. She has turned on its head the old architectural dictum that 'form has to follow function'. Her buildings can be a work of art, but time will tell whether the design will weather the Glasgow weather. I hope the gamble pays off.

48. The SSE Hydro (2013), Exhibition Way, G3 8YW

On the same site and next to the Armadillo, is the SSE Hydro. In 2014 it was said to be the second busiest of any of the world's great music venues (behind London's O2 Arena). That year it issued more than a million tickets. The arena was a product of the continuing demand for concert space. These were previously held in the SECC but it was just couldn't cope with demand. The building has seating for 12,500 and is the largest arena in Scotland.

The building is by Sir Norman Foster & Partners and Arup Scotland. It very definitely 'follows function' as it was designed specifically to allow maximum vision for the audience. I can confirm this from a James Taylor concert. The bulk of the seating is to the front of the stage but also wraps around it. There is a view from every seat and it is much more satisfactory than using football or rugby stadiums, where the action takes place over a large pitch.

The façade of the buildings incorporates 'foil pillow' cladding made from ethylene tetraflouroethyline (ETFE), a polymer that allows light to penetrate but at night images can be projected onto the surface. LED lights make it glow in rainbow colours. This is the material used on Cornwall's Eden Project.

Strangely, I don't think that Glaswegians have come up with a nickname yet, but it is only a matter of time.

SSE Hydro.

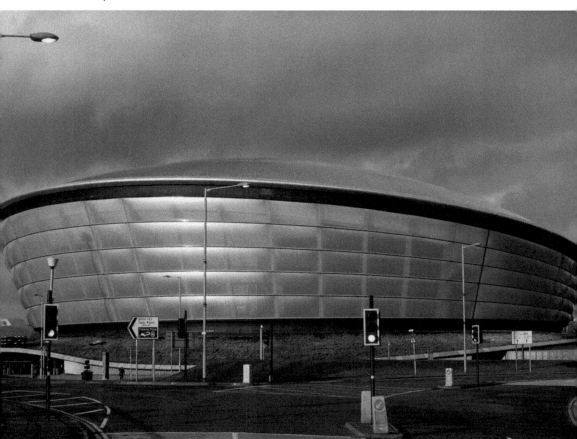

49. Scottish Power Headquarters (2015), No. 320 St Vincent Street, G2 5RZ

I am not yet sure what to make of this building, which is now Glasgow's largest. I was brought up in this area, not a half mile from the site. I watched while the area was 'redeveloped' in the 1960s and we ended up with desperate, brutalist, office blocks, when once there were Edwardian and Victorian buildings.

In the archive image you can see both Clive House, occupied by Strathclyde Regional Council, and the Royal Exchange Assurance building on the right.

The new building is the headquarters of Scottish Power, which is moving from the South Side. The building will house its 1,900 staff. The derelict site on which it is built was once the headquarters of Strathclyde Regional Council. The building is the product of collaboration between Page Park Architects and Ortis León Arquitectos of Madrid.

The building and the St Vincent Plaza in front, represent Glasgow's growth as a commercial and financial centre. I am quite sure that Glaswegians will debate the building intensely and will probably give it an appropriate name. They may even come to like it. Time will tell, but bear in mind that many of us have lived through the period of Scottish brutalism and do not now easily forgive poor architecture. After all, we are the experts. I think it needs a quirky structure on top to sell it.

The new Scottish Power Headquarters stands behind Keppie Design's new 2015 St Vincent Plaza. *Inset*: The same landscape, *c.* 1964.

I lived in Anderston as a lad and it was from there that we were 'decanted' to leafy Knightswood as a product of the Anderston Comprehensive Development Plan implemented in the 1960s. This was the result of plans to improve the city.

Our buildings went, as did many others, unnecessarily carving up Anderston with concrete roads and bridges, big and small, and some going nowhere at all!

It was with amazement that I returned to Argyle Street to see what had recently been achieved by Sanctuary Scotland in this latest £50 million regeneration of Anderston. I say latest, as houses were put up in this area in the late '60s. These buildings suffered the same fate as many other high and low-rise flats: poor building standards, resulting dampness.

What has emerged is a return to the 'streetscape', where houses front a street and become a community once more. These buildings are well designed and pleasing to the eye with their honey coloured block facings. Buildings include lifts, street space and public art and sensitive lighting is a pleasing feature.

They have been built in several phases by a number of architectural companies, including Collective Architecture and Cooper Cromar. The masterplan is for 500 homes close to the city centre. The fourth phase will create more houses on St Vincent Street when the land is cleared and the existing blocks are demolished.

Glasgow in the 1950s and 1960s was not an attractive place to live, but plans were afoot to do something about it. While the Glasgow Garden Festival was credited as a real starting point for this in the mind of the Glaswegian, the plans were actually already underway. Maybe locals didn't really have a full understanding of what was planned, but when they woke up the sparks began to fly.

The Bruce Report covered two reports put together by the city engineer and Master of Works, Robert Bruce: the First Planning Report and the Clyde Valley Regional Plan. Had they been fully implemented then you would hardly have been able to recognise the city.

At the centre of the recommendations in the report were radical and alarming proposals to demolish a large section of the city centre. Among the proposed things to go were the Glasgow School of Art, City Chambers, Central Station and the Glasgow Art Galleries!

As Glaswegians will know, the above didn't happen but a great deal of what Bruce wanted did happen. He sought a new 'healthy and beautiful city'. How the destruction of the Art School would have achieved this is anyone's guess.

There is absolutely no doubt that the slums had to go. We were part of it. My family was moved in 1964 from North Street in Anderston to leafy Knightswood. My cousins from McIntyre Street went to a very early Easterhouse. Mrs Boyle from the next landing went to East Kilbride when it was just one street, or looked it. We visited her once. Granny Durning went to Easterhouse from Brigton.

It was time for change, but change was about to be forced on the city fathers through the New Towns Act. This was a government initiative to tackle the issues of inner-city overcrowding head-on by wholesale movement of populations to new

Argyle Street.

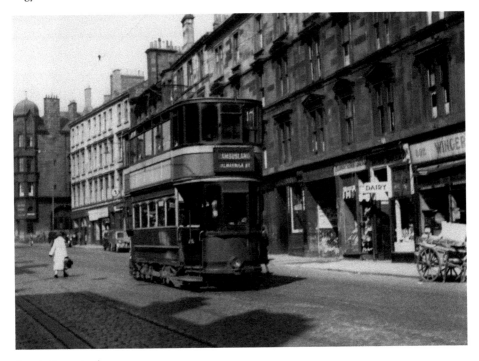

Argyle Street in the 1950s.

towns of East Kilbride, Cumbernauld and Irvine in the West and Glenrothes and Livingston in the East. In order to facilitate this, no new build was to be allowed inside Glasgow city. So, while there were existing 'schemes', such as Nitshill and Knightswood, there were to be no more massive housing estates within the city boundaries. The Glasgow residents would be rehoused in new towns outside the city. All of this was seen by the Glasgow Corporation councillors as a move to undermine the power of what was one of the largest city councils in Great Britain. Glasgow Corporation knew that the New Towns Act was on the way and the Bruce Plan was the alternative vision of what should happen to the city.

Ultimately the government won and the New Towns Act was enforced, at once creating East Kilbride, Cumbernauld and Irvine and ultimately cutting Glasgow's population in half.

One major thing that was done was the complete demolition of Glasgow's 'slum' housing and for the residents to be rehoused in new towns, or in the new housing schemes on the outskirts of the city – some say that these were to become the new slums!

Glaswegians will be familiar with the M8 and the Kingston Bridge, as well as the M74. I would certainly take exception to the fact that we were moved from our 'slum' tenement to make way for the Kingston Bridge, for our building was far from being a slum and was equal to many of the buildings still standing (and since renovated) in Anderston and Partick. We even had an inside toilet and a bath! 'Oor hoose' certainly wasn't big enough for a family with four boys and the move was our chance for a new start away from the smog of the inner city.

Still, the M8 was built and we were moved. While the building of the motorway through Anderston, Cowcaddens, Kingston, Tradeston and Govan did mean the removal of much of Glasgow's poor housing, it also meant the removal of many fine buildings, particularly at Charing Cross, including the whole east side of my own North Street.

What is not realised is that the M8 through these areas and the M74 in the south and east was only part of what was to be an inner ring road; this road was to go through many of the 'leafy' parts of Glasgow. There was such an outcry that the rest of the inner ring road initiative was shelved (including a proposed motorway through Maryhill and North to Balloch!).

It has taken forty years for the completion of the link from the M8 to the M74. While it is not the exact route suggested by Bruce, the link is now there.

Both of these photos show one of Anderston's surviving buildings, the Glasgow Savings Bank (1900), a Glasgow-style building and one of the city's finest ornamented tenements. This is the work of Salmon and Gillespie and features fine carvings as well as a brilliant mosaic above the main entrance.

Postscript

I wanted to complete this architectural journey through Glasgow with Anderston because I grew up there, and while our move to Knightswood was successful, I became very aware of the reasons for moving and how it all seemed so unnecessary. We can't go back but we can recognise the mistakes and protect what is left of our great city; we have some wonderful places.

In this journey we have seen some amazing buildings representing the city through the ages: from its medieval religious past to its emergence as a financial and commercial centre. The only problem was in choosing from the wealth of great architecture. While there are precious few buildings remaining from the city's early days, we certainly have a portfolio of buildings representing the best of Georgian, Victorian and Edwardian Glasgow. We also have many that represent Glasgow's great architects, of which Mackintosh and Thomson are on the most well known.

In common with other cities such as Birmingham, '60s and '70s Glasgow produced some dreadful designs to solve misunderstood problems. However, we are moving on from that, if you can ignore the dreadful battleship-grey call centre warehouses, mostly in the East End.

All along the Clyde, which resounded to the steam whistle, the call of the docker and the ring of the harbour, new well-designed buildings go up to once again show Glasgow as an exciting, vibrant and productive city.

No doubt mistakes will be made, but I am entirely sure that Glaswegians will now be keeping a close eye on their architectural heritage and it will be just as well known in the future for its design and its architectural experimentation as it is now.

Michael Meighan

Acknowledgements

In completing this book I have been indebted to all of those who gave me their opinions as to which buildings should be included. I wish I could have included them all.

Most of the images are my own responsibility, either taken by me or from my collection. I am indebted to Stewart Macartney of Blyth and Blyth for allowing me to use the image of Glasgow Central Station. Thanks to National Galleries of Scotland via Wikimedia Commons for the use of the Thomas Annan image of the Saltmarket.

I am, as always, indebted to Jill for proofreading and for her support.